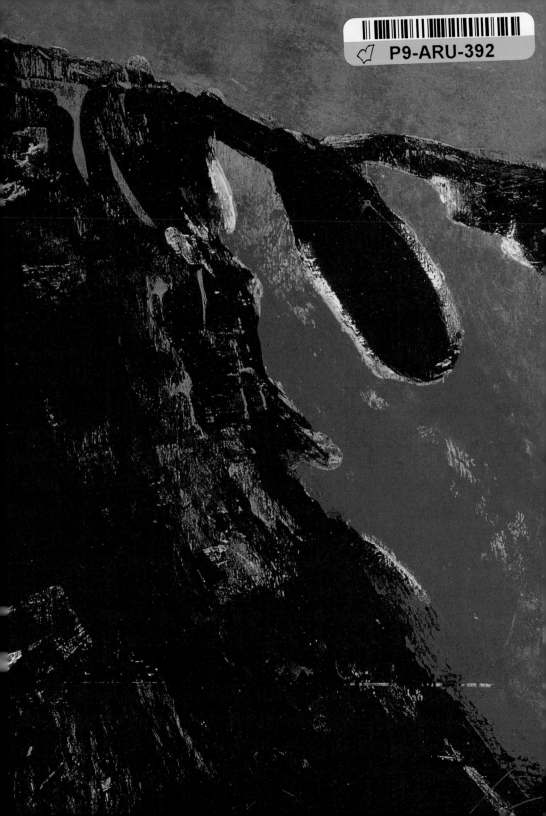

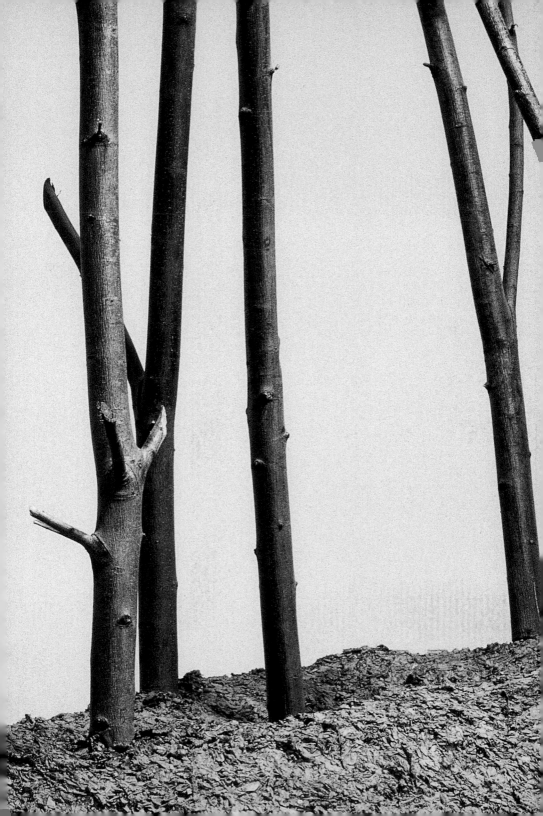

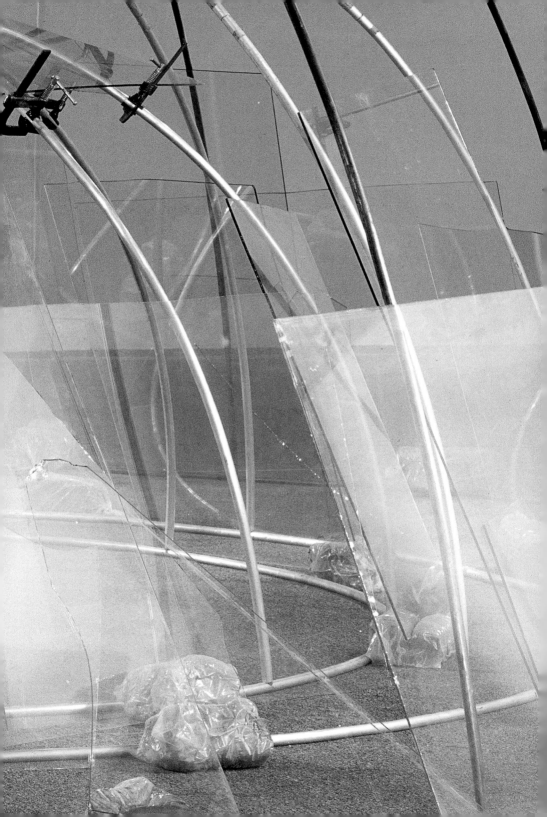

elements of
of
nature

elements
of
nature

Pierre Théberge in collaboration with Mayo Graham and Jonathan Shaughnessy

National Gallery of Canada, 2005

Published in conjunction with the exhibition *Elements of Nature*, organized by the National Gallery of Canada, Ottawa, Ontario, and presented at La Cité de l'énergie in Shawinigan, Quebec, from 11 June to 2 October 2005.

This catalogue has been produced by the Publications Division of the National Gallery of Canada, Ottawa.
Chief: Serge Thériault
Editors: Marnie Butvin (English) and Danielle Martel (French)
Translator: Danielle Chaput
Picture Editor: Andrea Fajrajsl
Coordinator: Anne Tessier

Designed and typeset in Avenir and Proforma by Fugazi, Montreal
Printed on EuroArt Silk and Classic Laid by St. Joseph Printing, Ottawa

Cover:
Giuseppe Penone, *I Have Been a Tree in the Hand* (detail, before completion) 1984–91, Musée d'art contemporain de Montréal.
Front Illustrations:
Paterson Ewen, *Solar Eruption* (detail), 1982, Montreal Museum of Fine Arts: 1
Jack Goldstein, *Under Water Sea Fantasy* (detail), 1983/2003, courtesy of Galerie Daniel Buchholz, Cologne: 2
Giuseppe Penone, *Breath of Leaves* (detail), 1982–83, National Gallery of Canada: 3
Mario Merz, *Triplo Igloo* (detail), 1984, Musée d'art contemporain de Montréal: 4
Interior Illustration:
Composite image of asteroid 243 Ida from Galileo spacecraft at range of about 3,400 km (detail): 14
Back Illustrations:
Hubble Space Telescope image of spiral galaxy NGC 4414, 60 million light-years away (detail): 93
Mars Exploration Rover Opportunity image of "Earhart" rock, Mars surface (detail): 94
Sun rising over the Pacific Ocean, seen from Galileo spacecraft at distance of 1.9 million km from Earth: 95
Extreme Ultraviolet Imaging Telescope image of solar plasma eruption, taken from SOHO spacecraft (detail): 96

ISBN 0-88884-809-9
Also available in French, ISBN 0-88884-810-2

Photograph Credits
Unless otherwise noted, photographs are provided courtesy of the lenders.

Ah Xian: 73 (bottom), 75, 76 (top)
Isaac Applebaum, courtesy of Susan Hobbs Gallery, Toronto: 39 (bottom)
Dina Carrara: 41, 46, 47
Denis Farley, Musée d'art contemporain de Montréal: 4, 24, 81
Courtesy of Galerie Daniel Buchholz, Cologne: 2, 53
Olivier Martin Gambier, courtesy of Fonds Régional d'Art Contemporain du Centre, Orléans, France: 23 (bottom)
Christine Guest, Montreal Museum of Fine Arts: 22, 44, 45
Hubble Heritage Team (AURA/STScI/NASA): 93
Achim Kukulies, courtesy of Galerie Johnen + Schöttle, Cologne: 23 (right)
Michel Legendre © Centre Canadien d'Architecture/ Canadian Centre for Architecture, Montreal: 78, 79
Liu Xiao Xian: 73 (top), 74, 76 (bottom), 77
Courtesy of Marian Goodman Gallery, New York: 48
Courtesy of McIntosh Gallery, University of Western Ontario, London: 60
Brian Merrett, Montreal Museum of Fine Arts: 1, 55
Trevor Mills, Vancouver Art Gallery: 38
NASA Jet Propulsion Laboratory: 14, 95
NASA Jet Propulsion Laboratory/Cornell: 94
National Gallery of Canada: 26, 58
Courtesy of Giuseppe Penone: cover
Bernhard Schaub, courtesy of Galerie Johnen + Schöttle, Cologne: 23 (left)
Axel Schneider, courtesy of Matthew Marks Gallery, New York: 21
Courtesy of SOHO/Extreme Ultraviolet Imaging Telescope (EIT) consortium. SOHO is a project of international cooperation between ESA and NASA: 96
Courtesy of Susan Hobbs Gallery: 37
Richard-Max Tremblay, Musée d'art contemporain de Montréal: 40
Irene F. Whittome: 78, 79, 82–83

Copyright Notices

Contents

Preface

It is now four years since La Cité de l'énergie embarked on a great adventure –
taking the century-old facilities of Shawinigan's former Alcan smelter and trans-
forming them into airy and expansive spaces for the exhibition of contemporary
art. We have been extremely gratified in working with the National Gallery of
Canada to draw a broad public to visit these spaces and participate in the marriage
of national heritage and art.

Elements of Nature is the third milestone in this initiative of La Cité de l'énergie.
The first was achieved in 2003 when we presented the National Gallery of
Canada's *The Body Transformed,* followed in 2004 by *Noah's Ark.* From explorations
of the human body, to the animal form, and now to the world of nature, we are
building on the increasing interest of visitors in experiencing art, and on our
mandate to offer a wide spectrum of cultural activities to diverse audiences. We
are very proud that this site has become a beacon to residents and visitors of
Shawinigan and the Mauricie region.

Major international artistic events like these could not take place without the
generous cooperation of the National Gallery of Canada and the enthusiastic
support of the institutions, collectors, and artists who agree to lend works to
the exhibitions. With their collaboration, La Cité de l'énergie once again takes
pride in offering the public an artistic and cultural event that further enhances
the reputation of Shawinigan and the Mauricie across Canada and beyond.

Robert Trudel
General Director
La Cité de l'énergie, Shawinigan

Acknowledgments

Once again, the National Gallery of Canada is pleased to mount a major exhibition in the renovated heritage buildings of the former Alcan aluminum smelting plant in Shawinigan, Quebec. Three buildings of this vast complex have been given new life under the direction of La Cité de l'énergie, whose association with us over the past three years has been the catalyst for a unique manifestation of exhibition outreach by the National Gallery of Canada, and for a remarkable community revitalization program. The leadership of the General Director of La Cité, Robert Trudel, and the dedication of his staff have been exceptional and have led to a most rewarding collaboration.

The architectural firms of Desnoyers Mercure et Associés, Montreal, and Sylvie Rainville/Renée Tremblay Architectes, Shawinigan, developed the fine building restoration concept and oversaw the transformation of the exhibition halls at La Cité during several stages, beginning in 2002. Artist and exhibition designer Paul Hunter has once again elegantly integrated our exhibition installation into these special spaces.

For this year's exhibition, *Elements of Nature*, we have focused on contemporary art, choosing work by thirteen artists from Canada, the United States, Europe, and Australia. The sculptures, paintings, films, and installations were selected by myself and Mayo Graham, Director of National Outreach and International Relations, with the assistance of Kitty Scott, Curator of Contemporary Art. Jonathan Shaughnessy, Curatorial Assistant, Contemporary Art, supported us and wrote the insightful introductory essay for this catalogue. Mayo Graham was also in charge of exhibition coordination, ably assisted by project manager Christine Sadler, while Daniel Amadei, Director of Exhibitions and Installations, coordinated project implementation with La Cité. The catalogue was produced under the direction of Serge Thériault, Chief of Publications, and was designed by François Martin of Fugazi, Montreal.

To each of the many other people who helped realize this year's exhibition, we extend our sincere thanks. Among these in Ottawa are Joanne Charette, Léo Tousignant, Louise Filiatrault, Christine Feniak, Mark Paradis, Diane Watier, Stefan Canuel, Marnie Butvin, Danielle Martel, Danielle Chaput, Andrea Fajrajsl, and Anne Tessier. In Shawinigan, particular mention must be made of Michel Trudel and Benoît Gauthier at La Cité.

The generosity and cooperation of the artists, the public and private lenders, and other collaborators who have supported this venture are gratefully acknowledged. A complete list is found on the following pages, but I would be remiss if I did not offer special thanks here to Marc Mayer, Guy Cogeval, Joanne DiCosimo, Matthew Teitelbaum, Kathleen Bartels, and Jorg Johnen. For their ongoing support of our outreach collaborations, we acknowledge with sincere appreciation the Board of Trustees of the National Gallery of Canada and the Department of Canadian Heritage.

It seems particularly fitting that *Elements of Nature* is presented in some of the most remarkable industrial heritage buildings in the heart of Shawinigan. This city did not exist until the end of the nineteenth century, when it emerged from the untamed forest, promising astute investors an abundant energy source harnessed through the powerful falls of the St. Maurice River. From 1898 to 1902, its waters gave rise in quick succession to a major hydro-electrical station, a renowned pulp and paper mill, and a world-class aluminum smelting factory: water, earth, and fire.

Pierre Théberge, O.C., C.Q.
Director
National Gallery of Canada, Ottawa

Lenders to the Exhibition

Ah Xian
Art Gallery of Ontario, Toronto
Canadian Guild of Crafts, Montreal
Canadian Museum of Nature, Ottawa
Jeffrey Deitch
Fonds Régional d'Art Contemporain du Centre, Orléans, France
Galerie Daniel Buchholz, Cologne
Galerie Johnen + Schöttle, Cologne
Marian Goodman Gallery, New York
McIntosh Gallery, University of Western Ontario, London
Montreal Museum of Fine Arts
Musée d'art contemporain de Montréal
Giuseppe Penone
Vancouver Art Gallery
Irene F. Whittome

Discourses of Fire and Ice: Elements of Nature and Contemporary Art

Jonathan Shaughnessy

The works of art that make up the exhibition *Elements of Nature* oscillate in a space in between the phenomenal and mysterious world of nature, and that world as it is conceived through the lens of culture. The dialectic between nature and culture has occupied artists since the first cave paintings demonstrated early humans' primitive engagements with the world around them. In the late nineteenth century, impressionism ceased seeking mimesis as the requisite tribute to nature, and in the early twentieth century, dada freed art from traditional forms and materials of representation. Today, contemporary art is more than aware of its discursive existence and the limits of its own conventions. From the context of much contemporary artistic practice, nature emerges as neither the conduit to the sublime (as it was for romanticism) nor the basis for truths or utopias to be found through its abstraction (as it was for modernism). The sculptures, installations, paintings, and multimedia works featured in *Elements of Nature* reveal that the "landscape" of contemporary art is at times less transcendent in aims, though no less inquisitive in intent, than that of its predecessors. Comprising diverse presentations by thirteen artists – the Canadians Paterson Ewen, Jack Goldstein, Osuitok Ipeelee, Liz Magor, Bernadette Ivalooarjuk Saumik, Michael Snow, Marc Tungilik, and Irene F. Whittome, and the international artists Ah Xian, Tacita Dean, Martin Honert, Mario Merz, and Giuseppe Penone – this exhibition takes the elements of nature as its guiding thematic to explore contemporary interpretations of a perennial subject for art: the natural world and our relationship to it.

Marking a concrete historical intersection of nature and culture, the galleries at La Cité de l'énergie offer a unique space for the consideration of how artists explore the elements of nature today. Situated at a noose in the St. Maurice River where a powerful waterfall beckoned to prospectors and artists in the late nineteenth century,[1] Shawinigan owes its existence to nature and to the thousands

of workers who in 1898 began construction on an enormous hydroelectric dam that would harness the power of Shawinigan Falls. This project, completed under the auspices of Shawinigan Water and Power (SWP), led to the establishment of the Municipality of Shawinigan in 1901.[2] Metallurgy was the first major industry to thrive on SWP's hydroelectric resources; Canada's first aluminum smelter was built at Shawinigan by the Pittsburg Reduction Company in 1902.[3] Pulp and paper and textiles would follow, making Shawinigan one of Canada's most prosperous municipalities in the first half of the twentieth century. By the second half, though, the city's prosperity had begun to wane. Today La Cité de l'énergie has restored the foundry, which now houses art rather than machinery. It is an appropriate monument not only to Shawinigan's contribution to Canadian industry, but also to the promise of nature that has been one of Canada's artistic legacies.

Elements of Nature opens with the original primordial element, in German artist

Fire, p. 21

Martin Honert's *Fire* (1992). Constructed of cast polyester resin, *Fire* is expressively lit by a neon tube that breathes life into the otherwise frozen stasis of the oranges, reds, and charcoals of its ornamental painted finish. Like Honert's other sculptures in the exhibition, *Fire* is emblematic of the extreme realism and deliberately refined presentation that are the hallmarks of his practice. Working primarily from photographs (either his own, as in *Fire*, or found images like a magazine advertisement that inspired his tent pieces in the exhibition), Honert aims to methodically reduce the expansive realm of subjective connotations of his source materials to their objective basis in external reality.[4] Combining curious veracity with obvious artificiality, his sculptures become referential icons for a common language or collective memory, the latter of which is, for Honert, specifically that of his native Germany. *Linden* (1990), for example, takes as its

Linden, p. 22

basis a tree of great importance in German folklore, while the region of the Ruhr where the artist grew up serves as the inspiration for many of his depictions of the natural and built environment.[5]

At first glance, *Fire* appears laden with primal and ritualistic connotations one might expect to be associated with an element that is both nurturing and destructive. Such connotations are contradicted, however, by Honert's trademark ornateness, bordering on, but never succumbing to, kitsch.[6] The artist explains that *Fire* aims to investigate how this element "is linked to a very pragmatic conception of life. In spring, the garbage is disposed of and burnt. The functional goes hand in hand with the ritual. This is what I was after and I accentuated it through the dimension of the work."[7] In its unceremonious paring down of the symbolic and the mystical to convey a controlled spectacle, Honert's depiction detaches itself from the subjective realm of personal memory and experience, and achieves pure frozen sign potential. As such, viewed at Shawinigan, *Fire* nods to the history of the foundry, where the visitor of a century ago would have been greeted by the heat and fire required to cast aluminum ingots. The articulate realism of Honert's sculpture awakens to Shawinigan's particular engagement with the elements and the cultural development that followed, revealing how the manipulation, normalization, and control of nature (whether out of necessity or habit) become the basis for all subsequent rituals of culture.

Rituals of culture and place inform a group of sculptures dealing with the second basic element, water, and its variations as snow and ice. The latter appear metonymically in the cut and broken glass pieces of the late Italian artist Mario Merz's *Triplo Igloo* (1984), presented here with three works by Inuit artists: Marc

The various motifs of my work are culled from my own life and the way I perceive the world in my endeavor to examine it.

Martin Honert

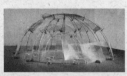

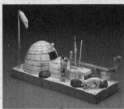

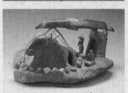

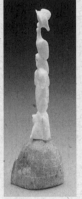

Tungilik's *Camp Scene* (1953), Bernadette Ivalooarjuk Saumik's *Igloo and Figures* (c. 1965), and Osuitok Ipeelee's *Tent Scene* (1977). The delicate monumentality of Merz's glass and aluminum structure is juxtaposed with the much smaller Inuit sculptures depicting dwellings and daily life through natural materials (stone, sinew, and ivory) combined with ink and copper nails from the south. The domed dwelling structure that Merz, Saumik, and Tungilik present is an archetypal one, associated not only with the Canadian north, in the form of igloos, but also with Merz's country of origin, in the form of *trulli*, the round stone dwellings of Etrurian shepherds found in the Apulia region of Italy.[8]

The archetypal symbol of the spiral is a base form for which Merz is best known. In *Triplo Igloo*, and in many of his sculptures, drawings, and paintings, Merz also used the mathematical theorem of twelfth-century monk Leonardo Fibonacci – which derives a numerical total from the sum of the previous two numbers in a chain – as a framework to organize the elements of his structures into a balanced and spiritual architectonic unity. Saturated with a conception of culture as humanity's basic relationship with the environment, Merz's igloos would often bring to their original gallery space natural and industrial objects local to the particular regions in which the artist was commissioned to work.[9] The conflation of the natural and the industrial within a pristine gallery space (especially that of

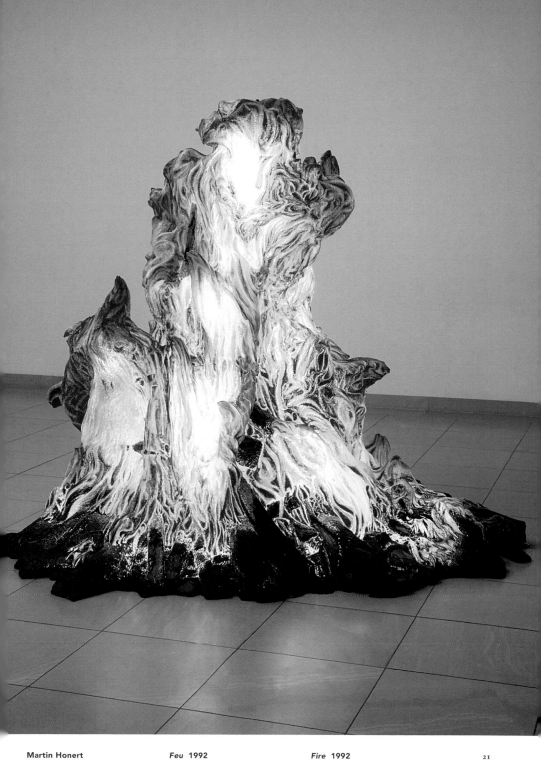

Martin Honert *Feu* 1992 *Fire* 1992

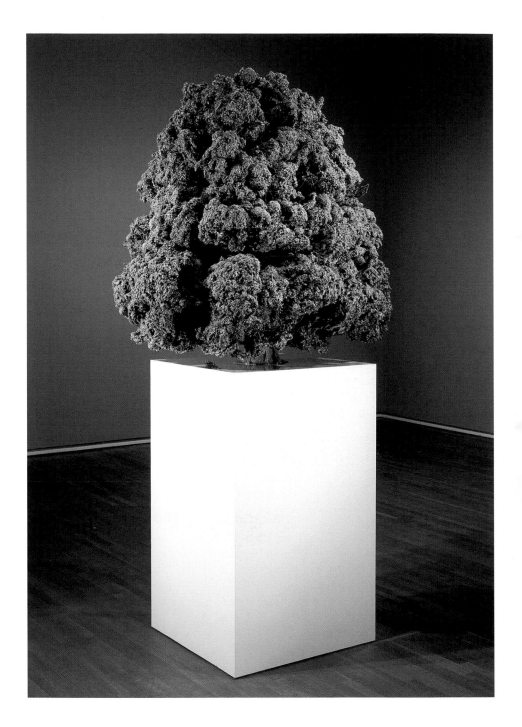

Martin Honert *Tilleul* 1990 *Linden* 1990

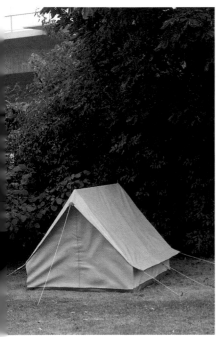

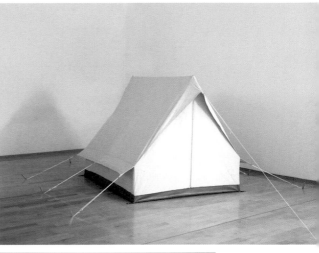

Martin Honert *Tente (version rigide)* 2001 *Tent (Hard Version)* 2001 23
 Tente (version souple) 2001 *Tent (Soft Version)* 2001
 Tente (maquette d'une *Tent (Model for an Outdoor*
 sculpture extérieure) 1991 *Sculpture)* 1991

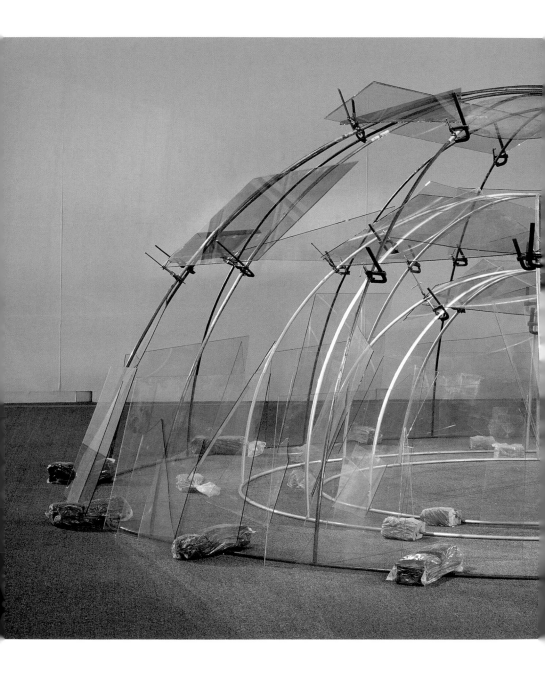

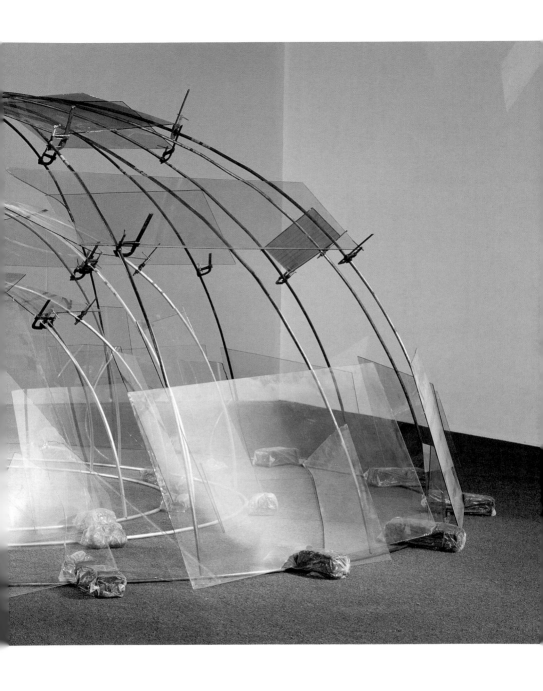

Mario Merz *Triplo Igloo* 1984 *Triplo Igloo* 1984

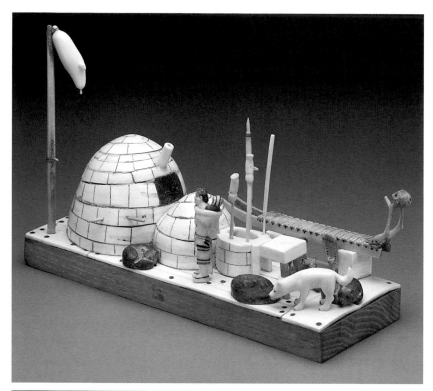

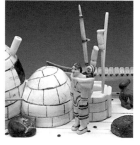

Marc Tungilik *Campement* 1953 *Camp Scene* 1953

Bernadette Ivalooarjuk Saumik *Igloo et figures diverses* *Igloo and Figures* c. 1965 27
 v. 1965

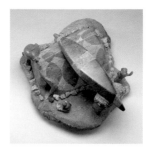

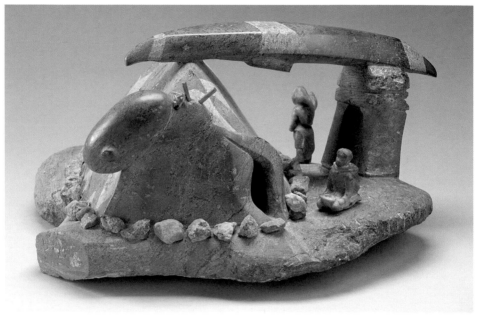

Osuitok Ipeelee *Campement* 1977 *Tent Scene* 1977

the "white cube" usually associated with modern and contemporary art exhibition) initiates a complex and emotive dialogue between nature, society, and art. In the context of the restored foundry in Shawinigan, which shares little in common with the "white cube," the dialogue that develops around Merz's work is more specific to humanity's relationship with nature, industry, and technology. In its suspenseful handling of materials – especially the broken glass supported by C-clamps that threaten to give way at any time – *Triplo Igloo*, like Merz's other igloos, becomes an intervention of sorts, aimed at no less than a fundamental re-examination of our relationship with nature in the late capitalist, post-industrial world.

Merz's handling of our cultural adaptation to the forces of nature creates a frame of reference that both parallels and contrasts with the Inuit works. Where Merz aims to stir the viewer with a nomadic sentiment unfamiliar to most Westerners' daily lives, Tungilik, Saumik, and Ipeelee reflect on semi-nomadic traditions that were disappearing from their daily cultural reality. Tungilik and Ipeelee's camp scenes are each in their own way realistic depictions of traditional Inuit life that, by the time of their creation, had shifted dramatically from migratory hunting and gathering to a sedentary reliance on modern food, tools, and shelter, a shift accompanied by significant changes in cultural knowledge. Tungilik's materials recall the small ivory figures, games, and trinkets that for centuries had been a staple of Inuit artmaking and trade; it was not until the 1950s, under the original impetus of James Houston, that an official art market was established between cooperatives in the North and cities in southern Canada. The Inuit works demonstrate the artists' contemporary awareness of artmaking as a specific form of expression capable of communicating, and in many ways recovering, past traditions and lifestyle; many of the subjects depicted by artists at this time, notably camp scenes, were extremely popular with collectors inter-

ested in purchasing an "authentic" depiction of Inuit life. In any respect, Tungilik and Ipeelee's sculptures are self-conscious records of a cultural interaction with the elements of nature, aimed at preserving or recovering what in Inuktitut is called *Inuit Qaujimajatuqangit*, or traditional Inuit knowledge.[10] The boats Tungilik and Ipeelee represent are good examples of such knowledge: with hulls made from animal hide, real boats were raised off the ground to keep them away from hungry sled dogs. Ipeelee uses small natural pebbles to show how rocks would afford a skin tent security against the elements, adding a functional layer of meaning to his work.[11] Merz's *Triplo Igloo* features similar rocks – in the form of small bags of clay – but against the structure's hollow cavity their placement is more ambiguous and functionally redundant.

Merz and the Inuit artists' igloos and tents create a subtext for *Elements of Nature* relating to the phenomenon, or phenomenology, of dwelling. These works present dwelling not in a theoretical sense, but rather as a fundamental necessity and a cultural response to the elements of nature; the viewer humbly realizes that

Tent (Hard Version), p. 23
Tent (Soft Version), p. 23
Tent (Model for an Outdoor Sculpture), p. 23

Cabin in the Snow, p. 37
Messenger, p. 38

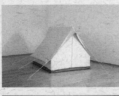
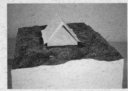

culture – a sense of identity and place – is intimately tied to basic human needs. On this point of the relationship between nature, culture, and shelter, Honert's tent works – *Tent (Model for an Outdoor Sculpture)* (1991), *Tent (Hard Version)* (2001), and *Tent (Soft Version)* (2001) – and Vancouver-based Liz Magor's two cabin installations – *Cabin in the Snow* (1989) and *Messenger* (1996–2002) – enter into a potentially competing dialogue with *Triplo Igloo* and the Inuit sculptures. While the latter would seem to posit shelter as a symbiotic relationship between humanity and nature, Honert and Magor's structures question the implications of this ideal in contemporary global consumer culture. Honert's *Tent (Hard Version)*, for example, was originally made as an installation in a parking lot, and was intended to "create a vexing contrast between the mobile surroundings and the completely static form in the middle of the clearing."[12] *Tent (Soft Version)* creates a similar vexation as an outdoor recreational object pitched inside the foundry's industrial-aesthetic space. These works refer less to an archetypal form of shelter and nomadic ways of life than they comment on the tent as the product of a contemporary "lifestyle" that seeks a certain experience of nature in its commodified form.[13]

Hollow, p. 39
Chee-to, p. 39

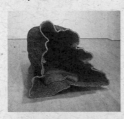

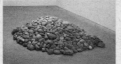

The commodification of both nature and culture dwells at the periphery of broader formal concerns in Liz Magor's artistic practice. *Hollow* (1998–99), *Chee-to* (2000), and the cabin installations are all seemingly realistic depictions of elements of nature, but Magor presents only enough reality to draw the viewer in, at which point "things do not line up."[14] The rocks in *Chee-to*, for example, are deceptive in their mass, being not real stones but a cast of lightweight polymerized gypsum. Adding to this artificiality is the popular junk food itself, as small orange nuggets

seep out from the crevices of the pile. Is the artist making what appears to be a fairly straightforward statement about the degradation of the environment in the service of human consumption? Perhaps. But as with *Hollow* (1998–99) – a polymerized gypsum cast of a felled Cortes Island cedar that would belie its pure artifice – it is difficult to know where the references and messages of such works point except toward a general societal culpability.[15] While Magor appears to be dealing in her works with issues of the commodification of natural resources and ecological destruction, what can be made of her flirtations with irony and parody?[16] Regarding *Chee-to*, Magor estimates it is the rocks that are the imposters and the junk food that is real, since its powerful flavour has the ability to evoke a visceral response in the viewer. For her, this kind of response challenges our tendency to "believe nature more than culture."[17]

The elements of nature appear in Magor's art as a carefully articulated fiction, the kind that, as critic Philip Monk suggests, "[mimes] the real only insofar as it produces a simulacrum of the real, not the thing itself."[18] The critically effective nature of Magor's simulations, however, is that they chase an authentic encounter with the sublime wonder of nature, even in full awareness of the potential futility of such a task. The sleeping bag inside *Hollow* represents an impossible – and stereotypically Canadian – dream, just as the idyllic snowscape in *Cabin in the Snow* remains elusive and untouchable, cordoned off from the viewer by the expanse of a window. *Cabin in the Snow* and *Messenger* both conjure up stereotypes of nature and the Canadian identity, while also alluding to survivalists and squatters who "opt out" of contemporary civilization's highly-technological mastery over nature. Of the urge to escape to backwoods cabins, Magor suggests:

> It's surprising that the country isn't dotted from coast to coast with these little forts. Per-
> haps it's the distilled version of solitude that daunts us. Only the over-proof are driven to

try it. For the rest of us, the *Cabin in the Snow* is best kept as an idea. A place where our true self resides knowing it has no real home in the world.[19]

Where Merz and the Inuit artists explore shelter as a cultural response to nature, Magor's dwellings tease us with visions of escape from culture. The idea of escaping from the cultural – from language and identity – into Nature's mysterious otherness is essentially a romantic one. Whether it is even possible, or ultimately worthwhile, remains an open question. Magor's practice – which is certainly not romantic, but is instead critically preoccupied with the infinitesimal links between nature, language, and identity – does not seek an answer. Rather, it indicates that the locus of romantic yearnings originates not in nature but in our cultural relations to it.

In contrast to the playful artifice in Magor's simulations of nature, Giuseppe Penone's aesthetic practice takes nature's own genesis and life processes as an integral component of creative expression.

I Have Been a Tree in the Hand, p. 40
Versailles Cedar, p. 41

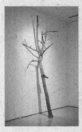 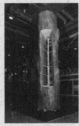

I Have Been a Tree in the Hand (1984–91), for example, documents seven years of a tree's growth around the sculpted mold of the artist's hand where it had once grasped the trunk. Penone first conceived of the "tree in hand" sculptures in his native Garessio, Italy, in 1968, the same year he made several other works involving living trees wrapped in wire, which aimed at recording their finite relationship to space and time. In *Versailles Cedar* (2000–03), Penone continues his life-long interest in nature's rhythms. After buying a tree that had been felled by lightning in the Forest of Versailles, Penone carved in it an opening the size of a door (which he calls an *arbre-porte*), to sculpt

the tree's interior back to its younger self by mapping out the knots of its later branches.[20] It was Penone's Garessio works that originally caught the attention of the art critic Germano Celant, who immediately included the artist in *Arte Povera*, an Italian artistic movement Celant founded in 1969, and to which Merz also belonged.[21] Reacting to mid-twentieth century art practices, especially in the United States, *Arte Povera* decreed that art should abandon its minimalist emphasis on the gallery space and pop concern for consumer culture. Instead, artists should engage in creative expression through the life force of the natural world, and nature's own processes should form an integral part of the work. This motive for creative production could not have been more like Penone's own. As Celant described:

> Animals, vegetables and minerals take part in the world of art. The artist feels attracted by their physical, chemical and biological possibilities, and...[feels] the need to make things in the world, not only as animated beings, but as a producer of magic and marvelous deeds. The artist-alchemist organizes living and vegetable matter into magic things, working to discover the root of things, in order to re-find them and extol them...Like an organism of simple structure, the artist mixes himself with the environment, camouflages himself, he enlarges his threshold of things. What the artist comes in contact with is not re-elaborated; he does not express a judgment on it, he does not seek a moral or social judgment, he does not manipulate it. He leaves it uncovered and striking, he draws from the substance of the natural event – that of the growth of a plant, the chemical reaction of a mineral, the movement of a river, of snow, grass and land, the fall of a weight – he identifies with them in order to live the marvelous organization of living things.[22]

While much of Penone's practice reflects the spirit of *Arte Povera*, especially in terms of his use of natural materials to represent natural matter, at the same time it reveals his unique fascination with the forms and limits of human bodily expe-

I began making these works about
the growth of trees. They are based
on the idea that the tree is a fluid
material that can be modelled. The
main vector is time...

Giuseppe Penone

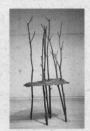

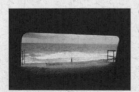

Breath of Leaves, p. 43 rience in the natural world. To create *Breath of Leaves* (1982–83), for example, the artist traced the contours of his own breath in a pile of leaves, then cast the intricate pattern in bronze. Supported by tree branches that appear to pierce through it, the bronze breath of leaves gives form and substance to an invisible and ephemeral bodily function that is intimately dependent on reciprocal plant processes. Penone describes this kind of realization of form as the basis for his art: "To solidify the currents of the blowing breath in space to prevent the disappearance of that space, taking into account all the possible and certain breaths that took place in time and space, is to make sculpture."[23] Such concretization of the ephemeral embarks on a poetic synchronicity and continuity between nature and culture as mediated by the artist's body, effectively bringing the viewer, as a corporeal being, toward an intimate awareness of and relationship with the elements of nature. In this respect, Penone's oeuvre stands as a romantic rebuttal to modernism's stark, impersonal aestheticism that, especially in architecture and minimalism, had abstracted nature so far from itself as to render it unrecognizable.

Modernism attempted, in architecture at least, to stand up to the elements of nature and exert a futuristic vision over their potentially destructive forces. British filmmaker Tacita Dean grapples with the legacy of modernism and its **Bubble House, p. 48** relationship with nature in her film *Bubble House* (1999), a meditative and methodical account of a modern architectural curiosity. The artist discovered a uniquely designed "bubble house" on the Caribbean island of Cayman Brac while she was compiling research for another work on the life and disappearance of novice yachtsman Donald Crowhurst.[24] Driving along the island coast,

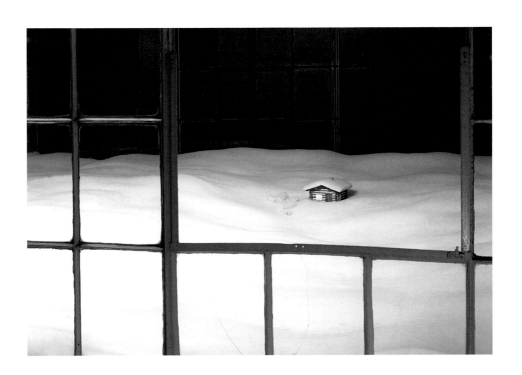

Liz Magor *Cabane dans la neige* 1989 *Cabin in the Snow* 1989

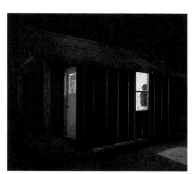

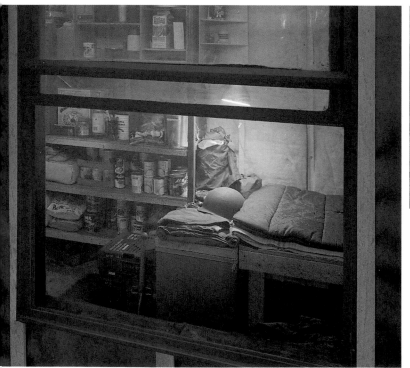

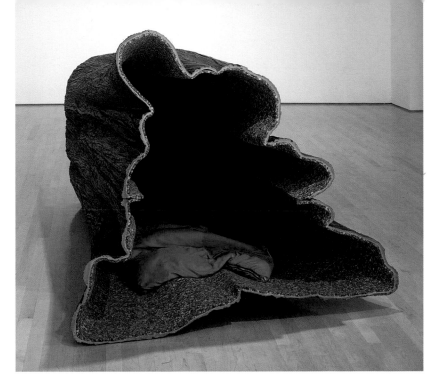

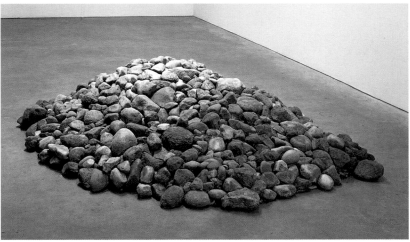

Liz Magor *Creux* 1998–1999 *Hollow* 1998–99 39
 Chee-to 2000 *Chee-to* 2000

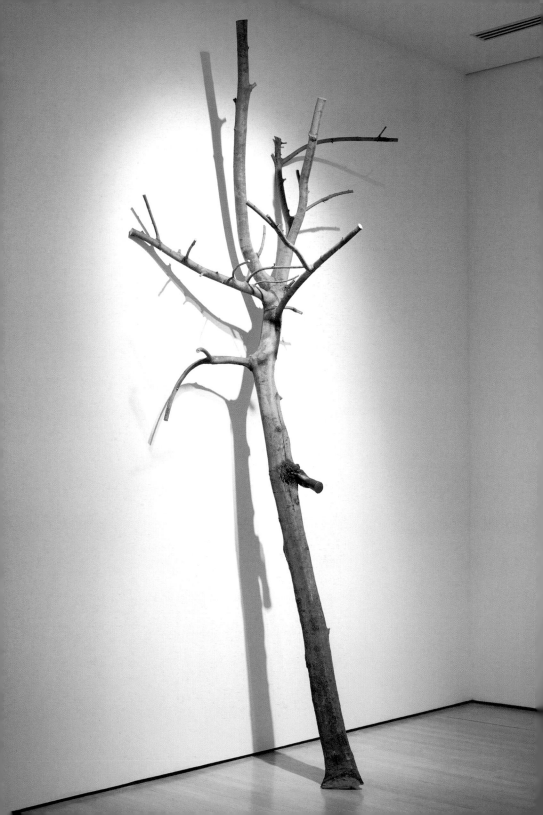

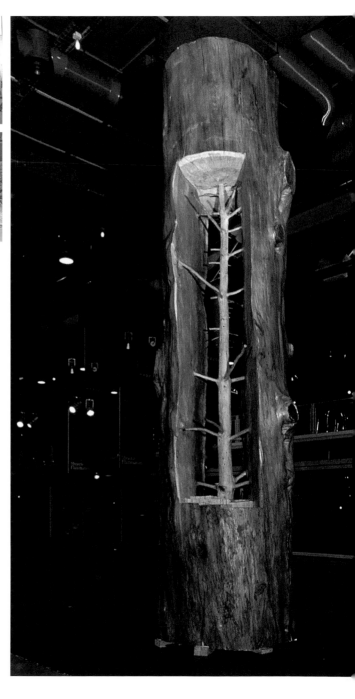

Giuseppe Penone *Je fus un arbre dans la main* *I Have Been a Tree in the Hand* 41
 1984–1991 (gauche) 1984–91 (left)
 Cèdre de Versailles 2000–2003 *Versailles Cedar* 2000–03

Giuseppe Penone *Souffle de feuilles* **1982–1983** *Breath of Leaves* **1982–83**

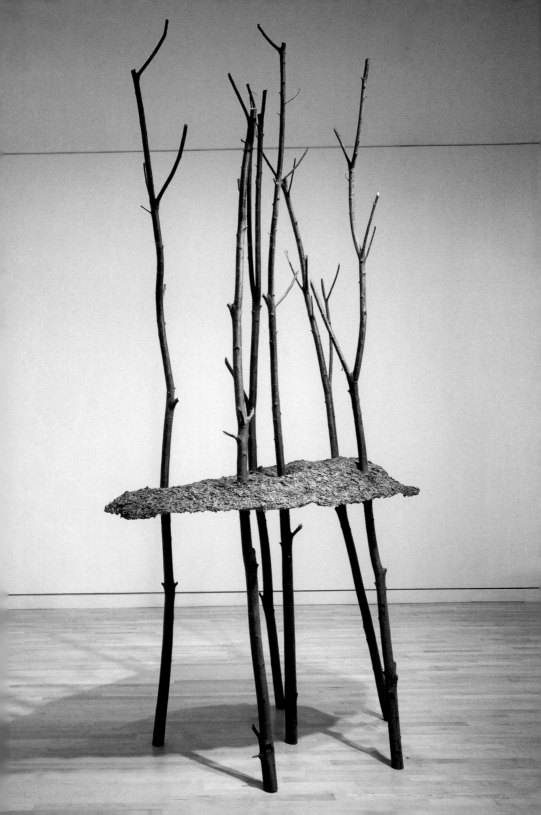

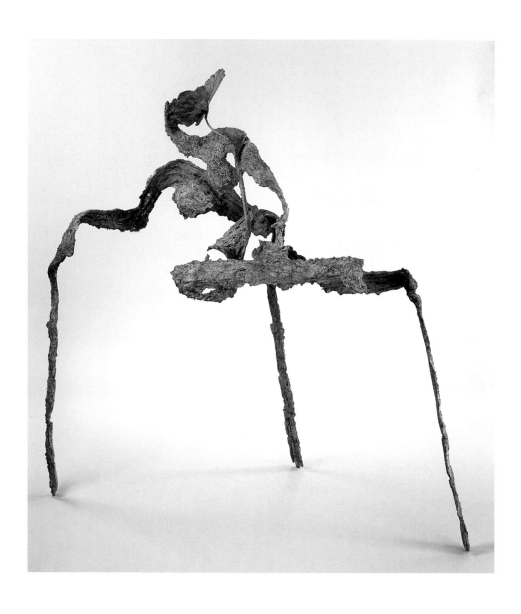

Giuseppe Penone *Grand geste végétal* 1983 *Large Vegetal Gesture* 1983

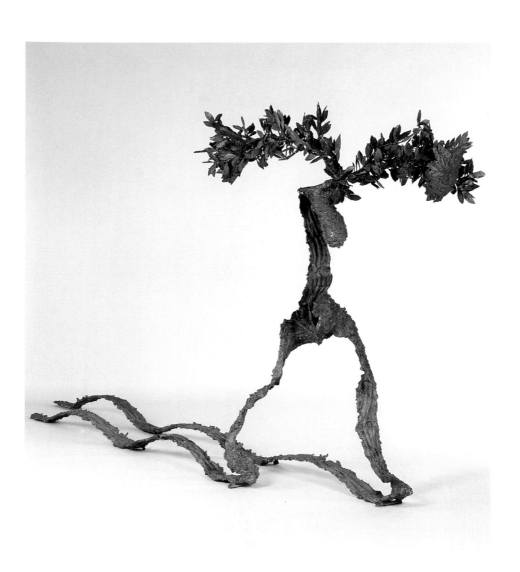

Giuseppe Penone *Sentier* 1983 *Path* 1983 45

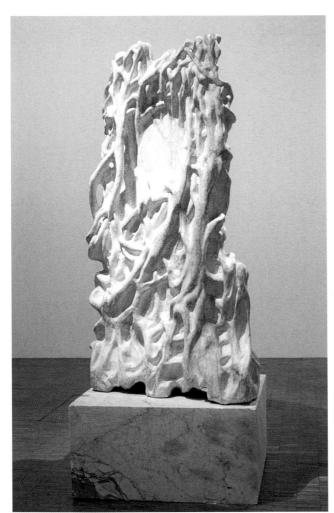

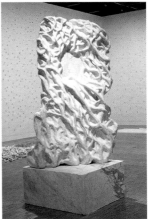

Giuseppe Penone *Anatomie 5 1994* *Anatomy 5 1994*

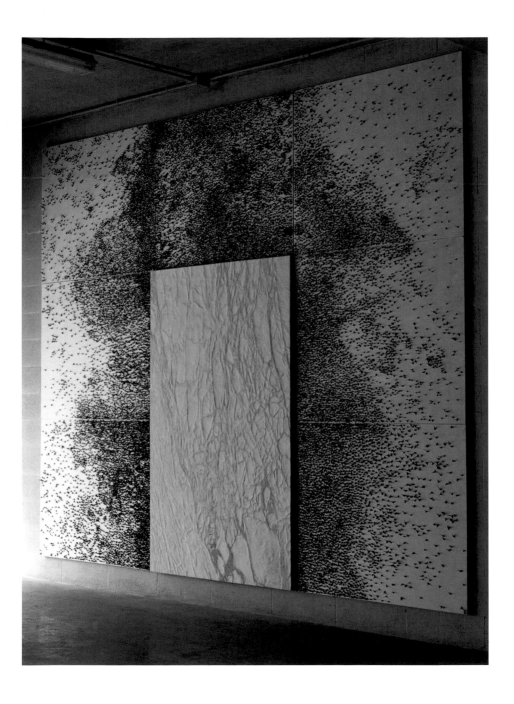

Giuseppe Penone *Peau de marbre et d'épines d'acacia* 2001 *Marble Skin and Acacia Thorns* 2001 47

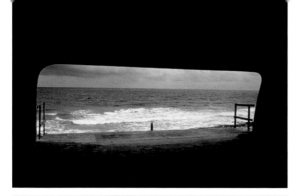

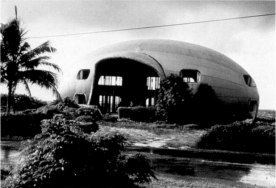

Tacita Dean *Bubble House* (photos de *Bubble House* (production
 tournage) 1999 photos) 1999

I was very blessed for *Bubble House*, because of the storm coming in... In fact it happened because of the storm...That was the event.

Tacita Dean

Dean came upon the "bubble house," as locals called it – the intact shell of an egg-shaped structure held to be impervious to the elements, especially the hurricanes that regularly besiege the island.[25] In a slow and deliberate analysis of the structure, Dean's film reintegrates the remnants of the building's incongruous exterior with the expanse of its natural surroundings. An approaching storm begins to strike the building's hollow cavity, deflating its modernist promise of utopia. Through the understated narratives of her cinematic practice, Dean subordinates the process of filmmaking to the specifics of space and time, emphasizing the obsolescence of her chosen subjects. Curators Virginia Button and Charles Esche describe how the ruins in *Bubble House* "point to the frailty of human endeavour against the forces of nature...In Dean's work, attempts to order, rationalise, and control the environment, and, by inference, to control human destiny, are often set against images of nature, which conjure up notions of the untamed powers of the imagination and the unknown."[26] While *Bubble House* displays a contemporary ambivalence toward the aims of modernism and romanticism alike, the film still smuggles in a reverence for the natural world – accentuated through the sounds of thunder, rain, and crashing waves – that for centuries has inspired so much creative expression.

More overt in its reverence for nature is Montreal-born Jack Goldstein's *Under Water Sea Fantasy* (1983/2003), a six-minute film completed shortly before the artist's death in 2003. The films of Goldstein and Dean are linked through their common medium (Goldstein worked and Dean works specifically in film, rather than video), but each artist's formal approach to film differs dramatically. In contrast to Dean's slow, methodical depiction of her subjects in real time, Goldstein's filmic practice is more heavily contrived. Many of his films from the 1970s and 1980s are based on

Under Water Sea Fantasy, p. 53

found footage that is edited and heavily doctored through a variety of looping and rotoscopic animation techniques. Using filtered colours in *Under Water Sea Fantasy*, Goldstein creates a dramatic aestheticization of otherwise unremarkable documentary footage of *National Geographic* ilk, but without a voiceover to interfere with the film's striking and sonorous presentation of earth's origins and evolution. At the time of the film's original production in 1983, Goldstein was also making atmospheric paintings of natural phenomena, especially destructive forces such as lightning and volcanoes, using an airbrush to render a precise but overextended realism; the same stylization appears in the artist's treatment of colour in *Under Water Sea Fantasy*.[27] Although Goldstein did not deal exclusively with the subject of nature, he was nonetheless intrigued by the potential to recreate its forces through art; influenced in the 1980s by postmodern techniques of appropriation, Goldstein felt that artifice and dramatization of the elements of nature should be acclaimed rather than avoided. As he stated in a 1977 interview, in a kind of prophecy of 1990s Hollywood film:

> If I had all the resources of Hollywood at my disposal, I'd make weather films: blowing trees, twisting trees, floods, walking on the ocean. I would love to do a performance where a black cloud comes over a hill, and it would rain for thirty seconds. It would be like Moses making the Red Sea part. It's fantastic, it's just incredible, to be able to control nature. It's so artificial. I love it.[28]

While Goldstein only fantasized about these kinds of effects for his unmade weather films, the late Paterson Ewen gave them concrete form in his "phenomascapes" – monumental paintings of meteorological and cosmological phenomena conveyed through acrylic and off-the-shelf materials (primarily metal) on routered plywood.[29] Through a metonymy of materials and means, Montreal-born Ewen sought from the early 1970s to place natural phenomena

and the viewer on the same plane, less representing the wonders of nature than conjuring their effects for the viewer's, and undoubtedly his own, visual and emotional response. Seven of the resulting phenomascapes, including the

Sun Dogs, p. 54

National Gallery of Canada's newly acquired *Sun Dogs* (1989), constitute the only paintings in *Elements of Nature*, appropriately sharing space in the foundry's third room with a number of meteorites on loan from the Canadian Museum of Nature in Ottawa. These astronomical artifacts strike a sympathetic chord with Ewen's paintings, as the latter represent both terrestrial and celestial subjects and place a heavy emphasis on the physicality of their materials. Working from photographs, scientific texts, his own observations of nature, and at times, memories of works by other artists, Ewen would approach the plywood sheet with marker in hand and without visual aids, to synthesize his research and sketch the outlines that would become the routered image. His process was inspired by Japanese artists like Ando Hiroshige (1797–1858), whom Ewen estimated would "never try and depict" nature until "he had captured enough of it in all levels of his being, then he would go back and do it."[30] Ewen's phenomascapes are records of action, reflecting a veritable process of bringing into being, in an ontological sense, the physical and emotive presence of the natural

Tidal Wave, p. 54

phenomena represented. The paintings also reflect how nature can be both creative and destructive, and in this respect *Tidal Wave* (1989) takes on a renewed significance after the tsunami that devastated Southeast Asia in December 2004.

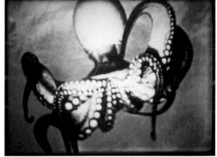

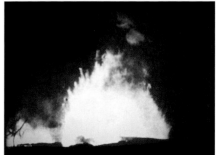

Jack Goldstein

Images fixes de *Under Water*
Sea Fantasy 1983/2003

Still frames from *Under Water*
Sea Fantasy 1983/2003

Paterson Ewen *Les faux soleils* 1989 *Sun Dogs* 1989
 Raz de marée 1989 *Tidal Wave* 1989

Paterson Ewen *Éruption solaire* 1982 *Solar Eruption* 1982 55

Paterson Ewen *Lune gibbeuse* 1980 ***Gibbous Moon* 1980**

Paterson Ewen *Lune au-dessus de Tobermory* *Moon over Tobermory* 1981
1981

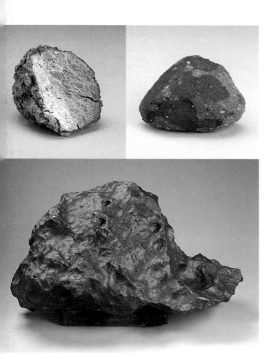

Météorite mésosidérite, Dalgaranga,
Australie occidentale
Météorite pierreuse de type III,
Pueblo de Allende, Mexique
Météorite sidérite, Canyon Diablo,
Arizona

Meteorite, mesosiderite, Dalgaranga,
Western Australia
Meteorite, type III stony, Pueblo de
Allende, Mexico
Meteorite, nickel iron, Canyon Diablo,
Arizona

Paterson Ewen *Galaxie NGC 253* 1973 *Galaxy NGC 253* 1973

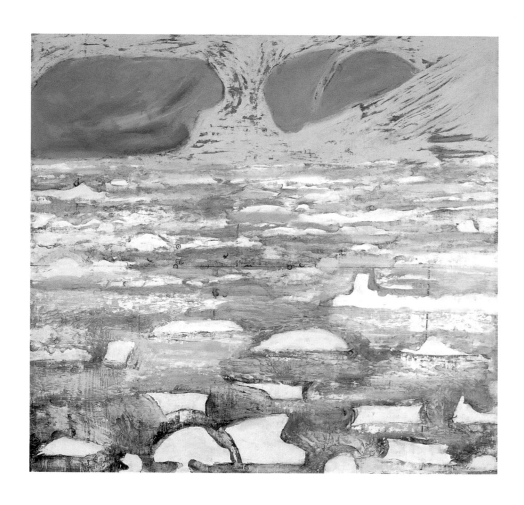

Paterson Ewen *Coulées de glace, Resolute* *Ice Floes, Resolute Bay* 1983
Bay 1983

By the late 1980s Ewen's paintings were becoming increasingly expressive, romantic, and sublime, even containing impulses toward religious or spiritual themes, as the artist described:

> I guess I'm a kind of pantheist: I believe God is nature. Sometimes when a painting becomes extremely difficult, I start to pray, not because I think the Almighty is concerned with this particular work, but because everything starts to fit in, as though it's been taken out of my hands. I may be doing the gestures, but when I'm working totally by instinct, I feel guided. It can be rationalized, I suppose, as the subconscious at work, but that doesn't take away from the sense of spiritual power.[31]

Ewen's words mark a turning point in this discussion toward the theme of spirituality or mysticism in relation to the natural world, an important subject in any consideration of aesthetics and the elements of nature. In both Eastern and Western artistic traditions, spirituality has almost always figured in representations of nature, albeit in differing ways, as curator Michiko Yajima explains: "Unlike Eastern philosophy's undivided fusion of *spirit* and *matter*, the Cartesian mind/matter dualism had profound and continuing influence on all facets of Western intellectual and cultural thought." One influence of the dualism that permeates Western thought is Empirical philosophy which, "grounded in the realm of the observable...denied a dimension that connects us to the essential nature of our own being, the spirituality of humankind."[32]

China-Bust 18, p. 73

Beijing-born, Sydney-based Ah Xian's ten porcelain busts from his *China, China* series (1999–2002) – rare recognizably human forms in *Elements of Nature* – cross the boundaries between Eastern and Western notions of philosophy and spirit. When Ah Xian left China for Australia following the

Tiananmen Square massacre in 1989, his practice included painting the nude – a deliberate act of dissention in a country then in the midst of purging all societal references to the West, where the nude has a long tradition. In self-imposed exile in Sydney, Ah Xian has been able to reflect on his cultural roots and return to them with fewer proscriptions against how he incorporates their influence in his artistic practice;[33] the results are the hauntingly beautiful porcelain busts on view here, which meld a western motif, the portrait bust, with the Chinese tradition of painting on porcelain.[34] The busts were cast in Jingdezhen, China, where most porcelain (i.e., china) has been historically produced, mainly for the decorative arts.[35] In his life-size representations of both Chinese and non-Chinese sitters, finished with landscape, mythical, and spiritual motifs traditional to the Ming (1364–1644) and Qing (1644–1911) dynasties, Ah Xian mixes and updates Eastern and Western traditions while reconciling both with his own diasporic identity. Writer Claire Roberts describes the effects of these works:

> The painted body casts unsettle the viewer by thrusting strong symbols of the past and present, as if the human being is inescapably branded with his or her own ancestry. Ironically, it is through traditional Chinese materials and practices that Ah Xian has found a rich and meaningful artistic language to communicate his ideas and his personal experience of cultural crossing in the late twentieth century.[36]

With eyes closed in contemplation, Ah Xian's figures are suffused with the airy lightness of traditional Chinese depictions of nature, which, as in the ancient practice of scroll painting, do not distinguish between the solidity of bodies, buildings, and mountains, and the immateriality of the sky; the animate and inanimate alike are imbued with energy and life force.

Linden/Tortue, p. 78
Anda/Stûpa, p. 79

The same kind of fusion of spirit and matter lies at the heart of Montreal-based Irene F. Whittome's multidisciplinary practice, which comprises an eclectic range of sculpture, painting, drawing, collage, assemblage, found objects, printmaking, and photography. Whittome's work invariably combines an interest in Eastern spirituality with investigations of Western epistemology and museum practices. For example, *Linden/Tortue* (1998/2005) features the turtle (a recurrent symbol in Whittome's work), which is associated with creation and other myths in the East and West alike, while *Anda/Stûpa* (1998/2005) carries Buddhist overtones and infuses the space of the foundry with a sense of the sacred.

Reflections of a Quarry, pp. 82–83

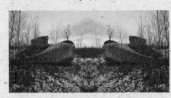

Reflections of a Quarry (2004/2005), an ambitious project conceived specifically for this exhibition and the Shawinigan site, marks a departure for the artist from the space of the museum and "back to the land."[37] The land in this case is the artist's recently purchased thirty-five acres of bush, including the abandoned Ogden quarry, near Stanstead, Quebec. In 1999, Whittome began to study and archive the industrial space of the quarry, establishing the basis for a number of photographic, sculpture, and excavation projects.[38] In *Reflections of a Quarry*, she continues her dialogue with history and artifact begun at Ogden by bringing an immense canusa grey granite stone excavated from the quarry to the foundry site. A mound of soil and a living tree in the stone attest to the regrowth of vegetation that, since the quarry closed in 1990,

has begun to reclaim a landscape denuded by industry.[39] Both *Linden/Tortue* and *Anda/Stûpa* have also been updated with stones from Ogden to reflect this new current in Whittome's practice. Echoing through the expanse of *Reflections of a Quarry* (and also accompanying *Anda/Stûpa*) are recordings from Ogden: indigenous environmental sounds laid over an ambient violin soundtrack performed at the quarry by New York-based musician Malcolm Goldstein, a former colleague of John Cage. Whittome conceived of the transfer of sound and stone from one industrial site to another as a transfer of energies, with the granite bringing energy from a quarry to a foundry that was itself a locus for the production of energy. Intrigued by the spectres of machines that once inhabited the foundry at Shawinigan, during her initial planning visit to the exhibition space the artist described "pockets of energy in the building – dead/alive – that [she] couldn't ignore" and that later influenced the placement of her works in the show, demonstrating the sensitivity to history and place that characterizes Whittome's career.[40]

Reflections of a Quarry marks a decisive encounter with the third primordial element, earth, infusing its mineral forms with a mystery and life-breathing potential not often associated with inanimate matter. Whittome's treatment of natural materials recalls the spirit of *Arte Povera* and has much in common with Merz and Penone; the veins of the marble in the latter's *Marble Skin and Acacia Thorns* (2001) come to mind.[41] In turn, the energy and material authenticity of her work contrast with the curious and deliberate affectation at the heart of Honert and Magor's depictions of nature. Consider, for example, Honert's *Linden* as it is seen in proximity to Whittome's very different presentation of the same subject in *Linden/Tortue*. In what sort of dialogue does the

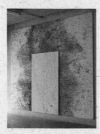

Marble Skin and Acacia Thorns, p. 47

flourishing artifice of Honert's tree, accentuated on a classical plinth, engage Whittome's denuded tree trunk? More broadly, what are the discursive possibilities of contemporary artistic practice, and how does this exhibition, set in an industrial site, reveal the equally discursive underpinnings of nature itself?

Discourse, a term used often in contemporary art theory, both implies and requires language. Today, and perhaps for the entire twentieth century in the West, the theoretical implications of language have extended to the far reaches of experience: of nature, of society, of ourselves. Some artists in the exhibition – Honert, Magor, and to a certain extent Tacita Dean – take this slippery realm of signification as the inescapable basis for artistic exploration of the natural world. In a related fashion, Tungilik, Saumik, and Ipeelee reveal a self-conscious awareness of the importance of language to Inuit's integral and vulnerable cultural understanding of nature. Other artists, in contrast – Merz, Penone, Goldstein, and Ewen – seem to want to shed the discursive in the interest of an unmediated experience of the environment and humanity's primal spirit. Ah Xian and Whittome's works are more anomalous, steeped in significations and plural contexts that make little headway against the reverence for nature embodied therein. Of course, general categorizations like these cannot do justice to the artists' diverse practices or the possible intentions of their works. The artifice of Goldstein's films, for example, and Penone's poetic manipulation of nature raise questions about how these two artists relate to the others. Is Goldstein dealing with nature or with the society of the spectacle? Do Penone's sculptures say as much about nature as they do about the creative power of the artist since the Renaissance, or even antiquity?[42] Questions like these demonstrate the inquisitive and even perplexing character of much contemporary artistic practice, one that allows viewers to reach many different conclusions about what representations of the environment may mean relative to the state of nature today.

In the end, *Elements of Nature* is about Nature: the world around us as it is perceived and represented by contemporary artists. Whether or not a "pure" experience of nature is possible is a matter of much debate, and the artists featured in the exhibition certainly take up the question in a variety of ways. The aim here is not to provide definitive answers, though, but to leave the question open to the viewer's consideration and to future discourse. To that end, the final works in the exhibition, in particular, offer the possibility of reconsidering, from entirely new perspectives, the ways in which we experience nature, and how those experiences are mediated by social and cultural conventions. In the foundry's third pavilion, two plasmascreen monitors present scientific images – the moon, nebulae, and galaxies (as viewed through the Hubble Space Telescope), and Mars, Jupiter, and Saturn's moon, Titan (taken during robotic explorations) – that encourage reflection on the most expansive and ephemeral of the four elements, air, while tantalizing us with the mysteries – and possibilities – of outer space.

La région centrale, p. 84

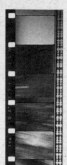

Even more disorienting of our perceptions and preconceptions is *La région centrale* (1970–71), a groundbreaking project that Michael Snow intended would be "a gigantic landscape film equal in terms of film to the great landscape paintings of Cezanne, Poussin, Corot, Monet, Matisse and in Canada to the Group of Seven."[43] By anchoring the camera to a mechanical armature that rotated a full 360 degrees, Snow represented the landscape in unsettling and unprecedented ways.[44] With this film, the artist wanted to achieve an "absolute record of a piece of wilderness," the kind of unequivocal encounter with nature (in this case, a remote, uninhabited mountain region in northern Quebec) that he believed was becoming increasingly rare: "This will feel like a record of the last wilderness on earth, a film to be taken

[*La région centrale*] will feel like a
record of the last wilderness on earth,
a film to be taken into outer space
as a souvenir of what nature once was...
a kind of Goodbye to Earth...

Michael Snow

into outer space as a souvenir of what nature once was. I want to convey a feeling of absolute aloneness, a kind of Goodbye to Earth which I believe we are living through."[45] With Snow's consummate farewell, this discussion concludes on a note of wonder and humility in the face of nature that, at the same time, causes pause at our unprecedented mastery over its elements.

Notes

1 In the 1860s William Notman's photographic lens brought the raw beauty of Shawinigan Falls to Montreal's attention, especially that of its wealthy prospectors and adventurers. In 1882 Lucius O'Brien visited the area around the St. Maurice River, canonizing the terrain's sublime wonder through a number of lithographs published in the early chronology of Canadian settlement, *Picturesque Canada* (1882). Many of Notman's photographs are held at the National Gallery of Canada, as are a number of O'Brien's depictions of Shawinigan Falls.

2 For a good account of the planning and history of Shawinigan, see Robert Fortier, *Villes Industrielles Planifiées* (Montreal: Éditions du Boréal, 1996).

3 In 1902 the Pittsburg Reduction Company formed a Canadian subsidiary, Northern Aluminum Company, which was re-incorporated as Alcan in 1925. "Alcan Aluminium Limited," Encyclopædia Britannica Online. <http://www.search.eb.com/eb/article?tocId=9005491> 13 March 2005.

4 For a good discussion of "objective" and external reality as it relates to Honert's artistic practice and the idea of memory, see Boris Groys, "A Self-Collector," in *Martin Honert* [ex. cat.] (New York: Matthew Marks Gallery, 2004): n.p.

5 Boris Groys, "Mind's Eye Views" [interview article], *ArtForum* (February 1995): 60

6 Honert is both conscious of his negotiation with kitsch and emphatic that his art avoids such connotations: "I know exactly when something becomes kitsch, and what I have to do to prevent that from happening. This is exactly the balancing act that interests me." Quoted in Groys, 60.

7 Quoted in José Lebrero Stals, "Martin Honert: Out of the Deadpan," *Flash Art* 26, no. 171 (summer 1993): 89.

8 Zdenek Felix, "The Power of the Imagination," *Mario Merz* [ex. cat.] (Essen, Germany: Museum Folkwang, 1982): 6.

9 Although Merz worked this way often, the Musée d'art contemporain de Montréal acquired *Triplo Igloo* after it was completed, not as a site-specific commission.

10 According to the Department of Culture, Language, Elders and Youth, "*Inuit Qaujimajatuqangit* is the Government of Nunavut's most important initiative. It encompasses all aspects of traditional Inuit culture including values, world view, language, social organization, knowledge, life skills, perceptions and expectations." "About the Department," Nunavut Department of Culture, Language, Elders and Youth. ‹http://www.gov.nu.ca/cley/english/department.htm› 26 March 2005. See also Christine Lalonde, "Introduction," in Christine Lalonde and Natalie Ribkoff, *ItuKiagâtta! Inuit Sculpture from the Collection of the TD Bank Financial Group* [ex. cat.] (Ottawa: National Gallery of Canada, 2005): 10–12.

11 I would like to thank Christine Lalonde, Acting Associate Curator of Inuit Art at the National Gallery of Canada, whose helpful discussion of these works forms the basis for the readings here.

12 Martin Honert, quoted in *Martin Honert* [ex. cat.] (New York: Matthew Marks Gallery, 2004): n.p.

13 This is especially apparent in the magazine advertisement source image for these works, published in the Matthew Marks Gallery *Martin Honert* catalogue (see note above); it presents a stereotypical and wholly contrived scene of a family camping beside a small river, with a Volkswagen Beetle parked next to the tent. In a sense, by removing the tent's association with advertising, and thus its status as a commodity, Honert only accentuates the structure's manufactured nature.

14 Liz Magor, interview by the author in Toronto, 25 February 2005.

15 As Shepherd Steiner points out, "Magor...summarily dismisses an ecological reading, not to mention a feminist reading, of her work." "Beating Around the Bush: Itnieraries for Identity, or Asymptomatic Structure in the Work of Liz Magor," in *Liz Magor* [ex. cat.] (Toronto: The Power Plant/Vancouver Art Gallery, 2002): 11.

16 Like Honert, Magor is quick to point out that she is not trying "to make kitsch things." Magor, interview.

17 Magor, interview.

18 Monk is referring here specifically to sculpture. "Playing Dead: Between Photography and Sculpture," *Liz Magor* [ex. cat.]: 62.

19 Liz Magor, "White House Paint," in *Real Fictions* [ex. cat.] (Sydney: Museum of Contemporary Art, 1996): 50.

20 Catherine Grenier, *Giuseppe Penone* [ex. cat.] (Paris: Éditions du Centre Pompidou, 2004): 287.

21 Penone discusses his inclusion in *Arte Povera* in Grenier, 257–59.

22 Germano Celant, *Arte Povera* (Milan: Gabriele Mazzotta, 1969): 225.

23 Quoted in Jessica Bradley, *Giuseppe Penone* [ex. cat.] (Ottawa: National Gallery of Canada, 1983): 60. Cited passage translated by Roberto Bolognese and Giuseppe Penone.

24 This research became the basis for two films by Dean, *Disappearance at Sea* (1996) and *Disappearance at Sea II* (1997), as well as the artist book *Teignmouth Electron* (London: Book Works, 1999).

25 According to Dean, the house itself was built by a French man who never completed it because fraudulent activities landed him in an American jail. Roland Groenenboom, "A Conversation with Tacita Dean," in Mela Davilá and Roland Groenenboom, eds., *Tacita Dean* [ex. cat.] (Barcelona and Actar: Museu d'Art Contemporani de Barcelona, 2000): 105.

26 Virginia Button and Charles Esche, *Intelligence: New British Art 2000* [ex. cat.] (London: Tate Britain, 2000): 45.

27 This connection between Goldstein's paintings and *Under Water Sea Fantasy* is self-evident, but also pointed out in Chrissie Iles, Shamim M. Momin, and Debra Singer, *Whitney Biennial 2004* [ex. cat.] (New York: Whitney Museum of American Art and Harry N. Abrams, 2004): n.p.

28 Quoted in Morgan Fisher, "Talking with Jack Goldstein," in Daniel Buchholz and Christopher Müller, eds., *Jack Goldstein: Films, Records, Performances and Aphorisms 1971–1984 / Filme, Schallplatten, Performances und Aphorismen 1971–1984* [ex. cat.] (Köln, Germany: Galerie Daniel Buchholz, 2003): 29. Interview originally published in 1977.

29 Ewen coined the term "phenomascapes" to describe his particular type of monumental landscape painting; "I call my work 'Phenomascapes' because they are images of what is happening around us as individuals, rain, lightning, hail, wind. They are also images of what is happening in and around our Universe, Galaxies, Solar Eruptions. They are sometimes inner phenomena. I observe, contemplate and then attack." Quoted in Philip Monk, *Paterson Ewen: Phenomena* [ex. cat.] (Toronto: Art Gallery of Ontario, 1987): 21.

30 Quoted in Nick Johnson, "Paterson Ewen: Rain," *artscanada* 32 (1975): 45.

31 Quoted in Dan Graham, "Twenty-Four Sketches of a Portrait of Paterson Ewen," in Michael Teitelbaum, ed., *Paterson Ewen* [ex. cat.] (Toronto: Douglas & McIntyre, 1996): 33.

32 Michiko Yajima, *Elementa Natura* [ex. cat.] (Montreal: Musée d'art contemporain de Montréal, 1987): n.p.

33 Claire Roberts notes, "In Australia, Ah Xian has found a degree of mental peace. There is no political harassment. He has said that he feels higher, closer to heaven." "Fishes and Dragons: Ah Xian's 'China.China' Series," *Art Asia Pacific* 26 (2000): 56.

34 For an elaboration on this mixing of artistic traditions see Roni Feinstein, "A Journey to China," *Art in America* 10, no. 2 (2002): 109.

35 It is a play on this distinction that is the basis for the name of Xian's series of busts, *China. China.* As Xian explains, "Some time ago I accidentally found a definition of where the English word 'China' came from. It was on the packaging for a Jingdezhen spirit wine. Jingdezhen was called Chang Nan (South of the Chang River) until the Northern Song dynasty (1004–07). The pronunciation of Chang Nan in Chinese and 'China' in English are almost the same. As evidence it's very important that the word 'China' also means porcelain. So, whether you believe it or not, I am at the place where the exact 'China' is. Quoted in Roberts, 56.

36 Roberts, 55.

37 All details of this work are derived from a series of telephone conversations between Whittome and the author in February and March 2005.

38 The first exhibition based on Whittome's exploration of the quarry was *Conversations Adru*, curated by Laurier Lacroix for the Art Gallery of Bishop's University, Lennoxville, Que., 12 May – 26 June 2004.

39 The tree was transplanted from its original location on another granite slab that was too large to transport to Shawinigan. Since the mound of soil the tree had grown from was shaped exactly like the cast bronze turtle shell in *Linden/Tortue*, with the cut slab of rock now accompanying that work, Whittome sees a direct formal and emotive parallel between the two sculptures.

40 It is not lost on Whittome that *Reflections of a Quarry* is situated close to where Louise Bourgeois' enormous bronze, stainless steel, and marble sculpture of a spider, *Maman* (1999, cast 2003), was situated in the 2004 Cité de l'énergie exhibition, *Noah's Ark*. Bourgeois has had an enormous influence on Whittome, who dedicated one of her early exhibitions to the American sculptor; Whittome's *Château d'eau: lumière mythique, 1997* (*Reservoir: Mythical Light, 1997*) (1997) also bears the influence of Bourgeois' *Precious Liquids* (1992). For a discussion of *Château d'eau* in relation to Bourgeois' work, and an image of the latter, see the exhibition catalogue of Whittome's work, *Bio-Fictions* (Quebec: Musée du Québec, 2000). The catalogue Whittome dedicated to Bourgeois was her collaboration with Jacqueline Fry, *Irene Whittome 1975–1980* (Montreal: Montreal Museum of Fine Arts, 1980).

41 The resonance between *Arte Povera* and Earth Art, which blossomed in the United States while *Arte Povera* was developing in Italy, might not have been far from Whittome's creative thinking in relation to the quarry and her new works. The artist is particularly intrigued by the American Michael Heizer, a pioneer of earth-based art, who is currently working on "City," a gargantuan project of land removal and reconstruction in the Nevada desert. See Michael Kimmelman, "Art's Last, Lonely Cowboy," *The New York Times Magazine*, 6 February 2005.

42 Giotto and Leonardo da Vinci are two artists in particular whose investigations into nature and human perception continue to intrigue Penone. See the informative and comprehensive interview with Penone in Grenier, 257–87.

43 Michael Snow, Canadian Film Development Corporation Funding Proposal, March 1969: 3. National Gallery of Canada curatorial files.

44 To create *La région centrale*, Snow collaborated with engineer Pierre Abbeloos, who constructed an armature that allowed the camera to move in a number of 360 degree patterns. This "Camera Activating Machine" is now the kinetic sculpture *De La* (1969–72) in the collection of the National Gallery of Canada.

45 Snow, funding proposal, 6.

Artist Quotations

P. 49 Tacita Dean, quoted in Mela Davilá and Roland Groenenboom, eds., *Tacita Dean* [ex. cat.] (Barcelona and Actar: Museu d'Art Contemporani de Barcelona, 2000): 105.

P. 19 Martin Honert, quoted in José Lebrero Stals, "Martin Honert: Out of the Deadpan," *Flash Art* 26, no. 168 (1993): 89.

P. 35 Giuseppe Penone, quoted in Catherine Grenier, *Giuseppe Penone* [ex. cat.] (Paris: Centre Georges Pompidou, 2004): 259. Translation by Danielle Chaput.

P. 67 Michael Snow, Canadian Film Development Corporation Funding Proposal, March 1969: 6. National Gallery of Canada curatorial files.

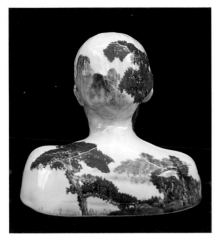
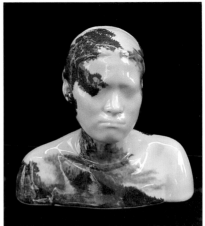
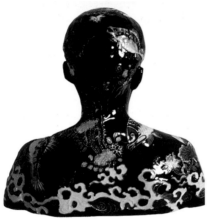
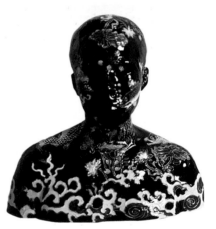

Ah Xian *Buste en porcelaine chinoise 18* *China-Bust 18* 1999 73
 1999 *China-Bust 21* 1999
 Buste en porcelaine chinoise 21
 1999

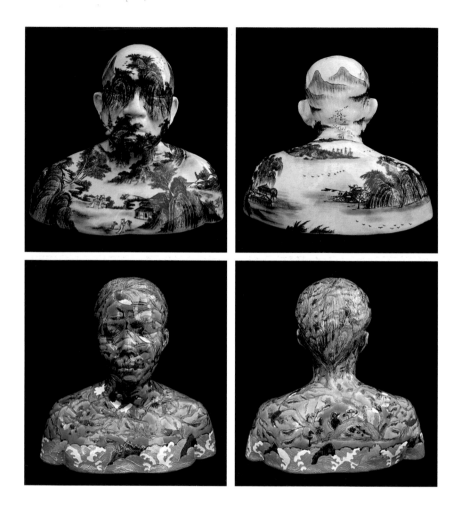

Ah Xian *Buste en porcelaine chinoise 22* *China-Bust 22* 1999
1999 *China-Bust 29* 1999
Buste en porcelaine chinoise 29
1999

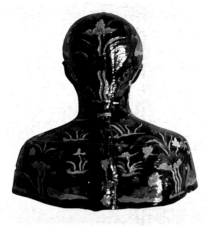
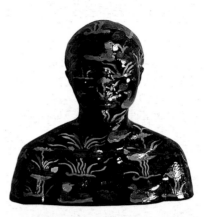
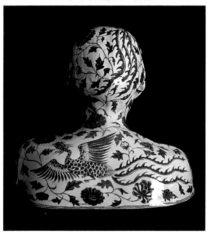
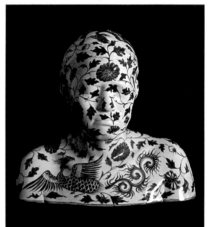

Ah Xian *Buste en porcelaine chinoise 30* China-Bust 30 1999
 1999 China-Bust 37 1999
 Buste en porcelaine chinoise 37
 1999

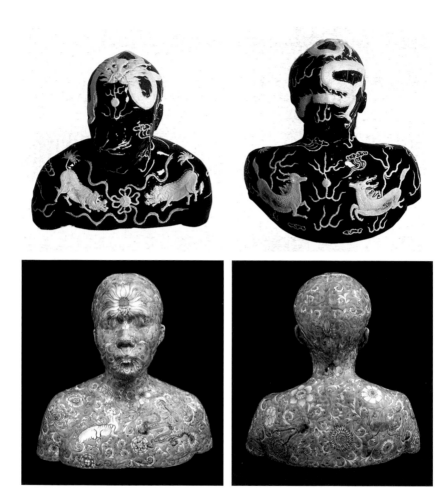

Ah Xian

Buste en porcelaine chinoise 43 *China-Bust 43* 1999
1999 *China-Bust 54* 1999
Buste en porcelaine chinoise 54
1999

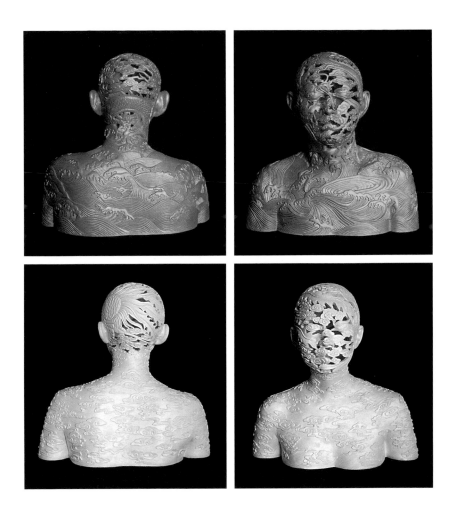

Ah Xian

Buste en porcelaine chinoise 61
2002
Buste en porcelaine chinoise 62
2002

China-Bust 61 2002
China-Bust 62 2002

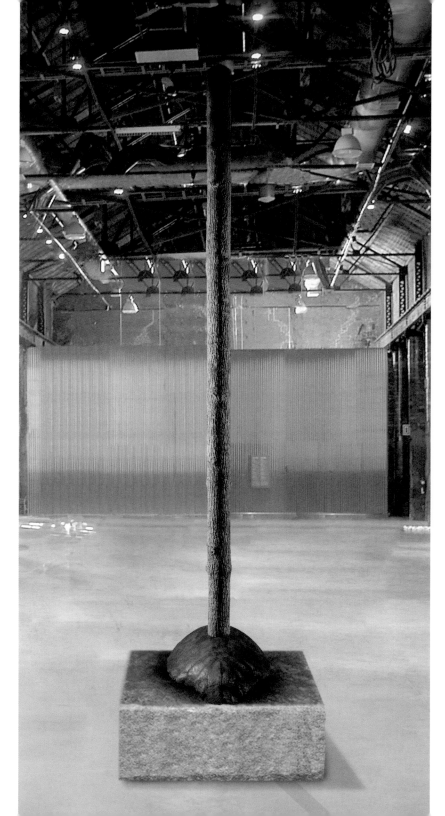

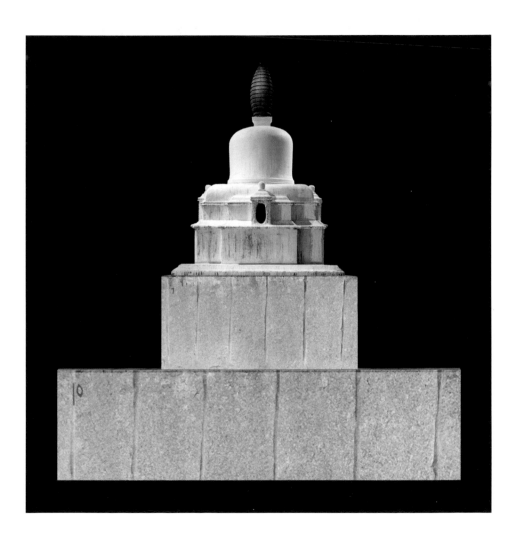

Irene F. Whittome

Linden/Tortue (image compo-
site) 1998/2005 (gauche)
Anda/Stûpa (image composite)
1998/2005

Linden/Tortue (composite
image) 1998/2005 (left)
Anda/Stûpa (composite image)
1998/2005

79

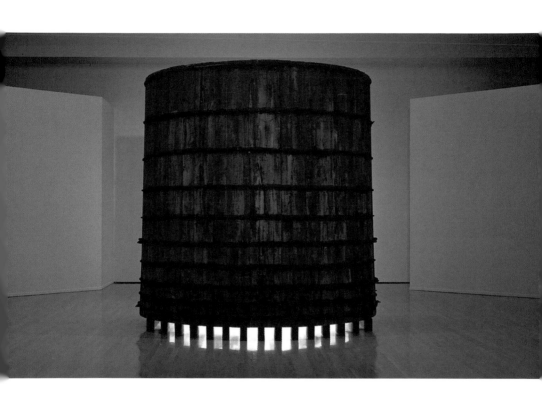

Irene F. Whittome

*Château d'eau : lumière
mythique, 1997* 1997

*Château d'eau: lumière
mythique, 1997 (Reservoir:
Mythical Light, 1997)* 1997

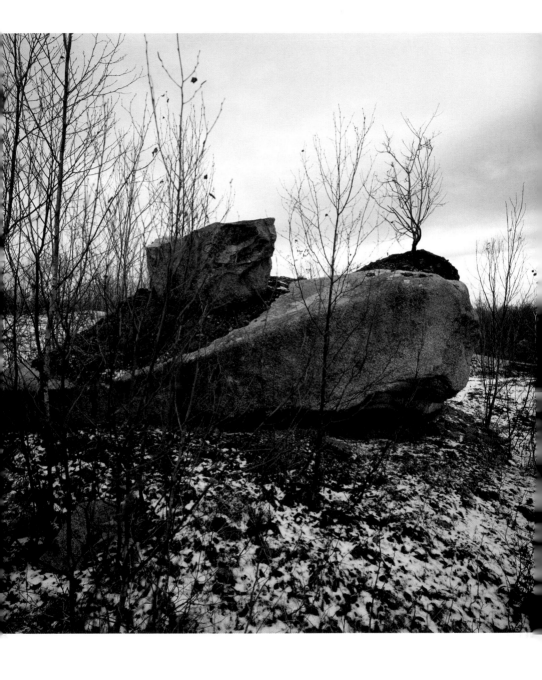

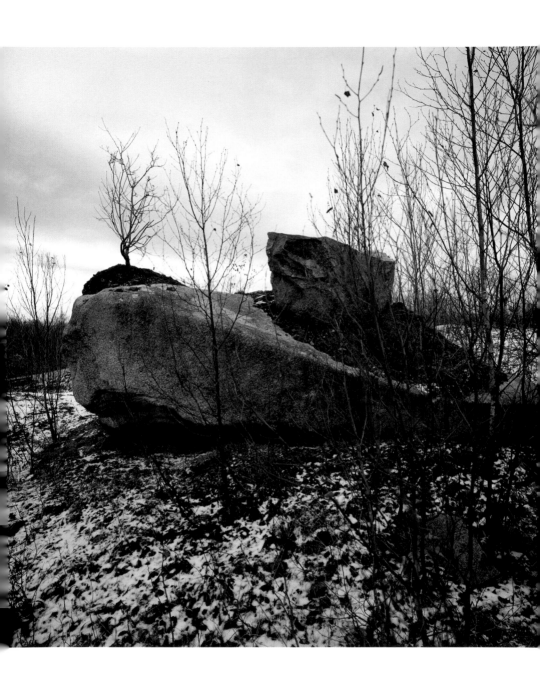

Irene F. Whittome *Reflets d'une carrière* *Reflections of a Quarry* 83
 (à Ogden, novembre 2004) (at Ogden, November 2004)

84 **Michael Snow** *La région centrale* (bande du film) 1970–1971 *La région centrale* (film strip) 1970–71

Works in the Exhibition

Ah Xian
China-Bust 18
1999
Porcelain with copper red
and cobalt blue underglaze in
landscape design
38.1 × 33 × 22.9 cm
Collection of the artist

Ah Xian
China-Bust 21
1999
Porcelain with high-fired
polychrome glaze on black
ground in fish and water weed
design
40.6 × 38.1 × 20.3 cm
Collection of the artist

Ah Xian
China-Bust 22
1999
Porcelain with cobalt blue
underglaze in landscape design
43.2 × 35.6 × 25.4 cm
Collection of the artist

Ah Xian
China-Bust 29
1999
Porcelain with low-fired
polychrome glaze in birds, plum
blossom, and ocean design
40.6 × 38.1 × 22.9 cm
Collection of the artist

Ah Xian
China-Bust 30
1999
Porcelain with low-fired
polychrome glaze in mandarin
ducks and lotus design
38.1 × 33 × 22.9 cm
Collection of the artist

Ah Xian
China-Bust 37
1999
Porcelain with copper red
and cobalt blue underglaze in
phoenix and lotus scroll design
38.1 × 33 × 22.9 cm
Collection of the artist

Ah Xian
China-Bust 43
1999
Porcelain with white paste-on-
paste on sacrificial blue glaze
in dragon and Chinese unicorn
design
45.7 × 40.6 × 25.4 cm
Collection of the artist

Ah Xian
China-Bust 54
1999
Porcelain with polychrome
enamel overglaze in four
deities and four seasons flower
scroll design
40 × 38 × 20 cm
Collection of the artist

Ah Xian
China-Bust 61
2002
Porcelain carved through with
low-fired matte gold pigment
in dragon and ocean design
40.6 × 40.6 × 25.4 cm
Collection of the artist

Ah Xian
China-Bust 62
2002
Porcelain carved through with
low-fired matte silver pigment
in phoenix and cloud design
40.6 × 40.6 × 22.9 cm
Collection of the artist

Tacita Dean
Bubble House
1999
16 mm colour film, optical
sound, 7 min
Courtesy of the Marian
Goodman Gallery, New York

Paterson Ewen
Galaxy NGC 253
1973
Acrylic, galvanized iron, and
string on plywood
243.7 × 228.5 cm
National Gallery of Canada,
Ottawa

Paterson Ewen
Gibbous Moon
1980
Acrylic on gouged plywood
228.6 × 243.8 cm
National Gallery of Canada,
Ottawa

Paterson Ewen
Moon over Tobermory
1981
Acrylic and metal on gouged
plywood
243.8 × 335.9 cm
National Gallery of Canada,
Ottawa

Paterson Ewen
Solar Eruption
1982
Acrylic on gouged plywood
243.8 × 228.6 cm
Montreal Museum of Fine Arts
(Purchase, Horsley and Annie
Townsend Bequest)

Paterson Ewen
Ice Floes, Resolute Bay
1983
Acrylic on gouged plywood
228.6 × 243.8 cm
McIntosh Gallery, University of
Western Ontario, London
(Purchase, Abbott Fund, 1984)

Paterson Ewen
Sun Dogs
1989
Acrylic and sprayed enamel
and galvanized iron on gouged
plywood
243.8 × 350.6 cm
National Gallery of Canada,
Ottawa

Paterson Ewen
Tidal Wave
1989
Acrylic on gouged plywood
267.2 × 433.1 cm
National Gallery of Canada,
Ottawa

Jack Goldstein
Under Water Sea Fantasy
1983/2003
16 mm colour film, 6 min 30 sec
Courtesy of Galerie Daniel
Buchholz, Cologne

Martin Honert
Linden
1990
Metal, synthetic foam, plastic
resin, paper, and paint
144.8 × 139.7 × 139.7 cm; on
base approx. 145 cm high
Montreal Museum of Fine Arts
(Purchase, Camil Tremblay
Estate and Horsley and Annie
Townsend Bequest)

Martin Honert
*Tent (Model for an Outdoor
Sculpture)*
1991
Polyester, plastic, lacquer, and
wood
30 × 60 × 80 cm; on base 80
cm high
Fonds Régional d'Art
Contemporain du Centre,
Orléans, France

Martin Honert
Fire
1992
Cast resin, fibreglass, oil paint,
and neon lights
245 × 205 × 205 cm
Courtesy of Jeffrey Deitch

Martin Honert
Tent (Hard Version)
2001
Polyester and steel
139.7 × 223.5 × 408.9 cm
Courtesy of Galerie Johnen +
Schöttle, Cologne

Martin Honert
Tent (Soft Version)
2001
Cotton, polyethylene, electric
fan, and mixed media
139.7 × 180.3 × 251.5 cm
Courtesy of Galerie Johnen +
Schöttle, Cologne

Osuitok Ipeelee
Tent Scene
1977
Light- and dark-green stone,
brown stones, and sinew
17 × 37 × 35 cm
National Gallery of Canada,
Ottawa
(Gift of M.F. Feheley, Toronto,
1985)

Liz Magor
Cabin in the Snow
1989
Installation with fabric and
model log cabin
305 × 668 × 762 cm approx.
National Gallery of Canada,
Ottawa

Liz Magor
Messenger
1996–2002
Wood, plaster, fabric, and
found objects
305 × 305 × 427 cm
Vancouver Art Gallery
(Gift of the artist)

Liz Magor
Hollow
1998–99
Polymerized alpha gypsum with
fibreglass, fabric, and foam
182.8 × 106.7 × 121.9 cm
National Gallery of Canada,
Ottawa

Liz Magor
Chee-to
2000
Polymerized alpha gypsum with
fibreglass, and cheesies
43.2 × 167.6 × 200.7 cm
Art Gallery of Ontario, Toronto
(Purchased with financial
support from the Canada
Council for the Arts Acquisition
Assistance Program, and with
the assistance of the E. Wallace
Fund, 2000)

Mario Merz
Triplo Igloo
1984
Aluminum, glass, clamps, and
clay
594 cm diameter
Musée d'art contemporain de
Montréal

Giuseppe Penone
Breath of Leaves
1982–83
Bronze, stainless steel, and
wood
375 × 167.8 × 111.7 cm
National Gallery of Canada,
Ottawa

Giuseppe Penone
Path
1983
Bronze
180.3 × 398.8 × 45.7 cm
Montreal Museum of Fine Arts
(Purchase, Horsley and Annie
Townsend Bequest)

Giuseppe Penone
Large Vegetal Gesture
1983
Bronze
160.02 × 139.7 × 99 cm
Montreal Museum of Fine Arts
(Purchase, Horsley and Annie
Townsend Bequest)

Giuseppe Penone
I Have Been a Tree in the Hand
1984–91
Wood and iron
396.2 × 165.1 × 139.7 cm
Musée d'art contemporain de
Montréal

Giuseppe Penone
Anatomy 5
1994
Carrara marble
210.8 × 109.2 × 50.8 cm
Collection of the artist

Giuseppe Penone
Versailles Cedar
2000–03
Cedar
602 × 170.2 cm
Collection of the artist

Giuseppe Penone
*Skin of Marble and Acacia
Thorns*
2001
Carrara marble, acacia thorns,
and silk
398.8 × 358.1 × 15.2 cm
Collection of the artist,
courtesy of the Marian
Goodman Gallery, New York

Bernadette Ivalooarjuk Saumik
Igloo and Figures
c. 1965
Grey stone and ivory with
black ink
18.7 × 5.8 cm
National Gallery of Canada,
Ottawa
(Gift of the Department of
Indian Affairs and Northern
Development, 1989)

Michael Snow
La région centrale
1970–71
16 mm colour film, 180 min
National Gallery of Canada,
Ottawa

Marc Tungilik
Camp Scene
1953
Ivory, stone, bone, copper
nails, and wood
20.32 × 12.7 × 30.5 cm
Canadian Guild of Crafts,
Montreal

Irene F. Whittome
*Château d'eau: lumière
mythique, 1997 (Reservoir:
Mythical Light, 1997)*
1997
Cedar, metal, mirrors, narwhal
ivory tusks, motor, and light
320 × 305 cm diameter
Musée d'art contemporain de
Montréal

Irene F. Whittome
Anda/Stûpa
1998/2005
Wood, cement, pigment,
granite base, and sound
367.6 × 325 × 157.5 cm
Collection of the artist

Irene F. Whittome
Linden/Tortue
1998/2005
Wood and bronze
494.7 × 127 × 137 cm
Collection of the artist

Irene F. Whittome
Reflections of a Quarry
2004/2005
Canusa grey granite, tree, soil,
and sound
254 × 295 × 81 cm
Collection of the artist

Meteorite, Canyon Diablo,
Arizona, USA
Nickel iron
9 × 9 × 6 cm
Canadian Museum of Nature,
Ottawa, Pinch Collection

Meteorite, Canyon Diablo,
Arizona, USA
Nickel iron
57 × 34 × 33 cm
Canadian Museum of Nature,
Ottawa, CMNR 70
Illustrated: p. 58

Meteorite (sliced as a block),
Coahuila, Mexico
Hexahedrite nickel iron
5.5 × 6 × 4.5 cm
Canadian Museum of Nature,
Ottawa, Pinch Collection

Meteorite (sliced at one end),
Dalgaranga, Western Australia
Mesosiderite
6 × 4.5 × 4.5 cm
Canadian Museum of Nature,
Ottawa, CMNR 60
Illustrated: p. 58

Meteorite (thin slice),
Etter, Texas, USA
Olivine, bronzite, chondrodite
19 × 16 × 0.7 cm
Canadian Museum of Nature,
Ottawa, CMNR 63

Meteorite (thin slice),
Landes, West Virginia, USA
Nickel iron with silicate
inclusions
9 × 9 × 0.7 cm
Canadian Museum of Nature,
Ottawa, CMNR 65

Meteorite, Odessa, Texas, USA
Nickel iron
18 × 18 × 7 cm
Canadian Museum of Nature,
Ottawa, CMNR 68

Meteorite (slice),
Odessa, Texas, USA
Octahedrite nickel iron
11 × 9 × 1.5 cm
Canadian Museum of Nature,
Ottawa, Pinch Collection

Meteorite (thin slice),
Odessa, Texas, USA
Nickel iron, coarse octahedrite
15 × 10 × 0.8 cm
Canadian Museum of Nature,
Ottawa, CMNR 67

Meteorite, type III stony,
Pueblo de Allende, Mexico
Carbonaceous chondrite
6 × 5 × 3.5 cm
Canadian Museum of Nature,
Ottawa, Pinch Collection
Illustrated: p. 58

Meteorite (thin slice),
Xiquipilco, Mexico
Nickel iron, medium
octahedrite
13 × 8 × 0.5 cm
Canadian Museum of Nature,
Ottawa, CMNR 66

Biographies

Ah Xian
Born 7 May 1960, Beijing, China. The self-taught Ah Xian has had several solo exhibitions, including his first in 1985 at the Old Observatory, Beijing, and the later *China Reconfigured: The Art of Ah Xian, with Selections from the Rockefeller Collection*, Asia Society and Museum, New York (2002–03). He has also participated in a number of group shows, among them *Mao Goes Pop: China Post-1989*, Museum of Contemporary Art, Sydney (1993), and *Now & Now: World Contemporary Ceramics, the Second World Ceramic Biennale 2003*, Icheon World Ceramic Centre, Korea. In 2001 he received the National Sculpture Prize from the National Gallery of Australia, Canberra, which was accompanied by an exhibition. Ah Xian has lived and worked in Sydney, Australia, since 1990.

Tacita Dean
Born 12 November 1965, Canterbury, U.K. Filmmaker Tacita Dean graduated from the Falmouth School of Art, Cornwall, in 1988 before studying at the Supreme School of Fine Art, Athens, on scholarship (1990) and the Slade School of Fine Art, London (1991–92). She held her first solo exhibition in 1994 at two Slovenian galleries, Galerija Stuc, Ljubljana, and Umetnostna Galerija, Maribor, and in 1997 showed at Witte de With Center for Contemporary Art, Rotterdam. In 1998 Dean was shortlisted for the Turner Prize, Tate Gallery, London, and in 2001 was nominated for a Millennium Prize and featured in the exhibition *Elusive Paradise: The Millennium Prize* at the National Gallery of Canada, Ottawa.

Paterson Ewen
7 April 1925, Montreal, Que. – 17 February 2002, London, Ont. Paterson Ewen is one of Canada's most celebrated artists. He studied at the art school of the Montreal Museum of Fine Arts in the 1940s, and in the 1950s, influenced by avant-garde movements like *Automatisme*, he became known for his abstract paintings. In 1968 he moved to London, Ontario, where he began making the innovative plywood paintings of cosmological and meteorological phenomena for which he is best known. During his five-decade career, Ewen exhibited extensively, won many prizes, and taught visual art at the University of Western Ontario, London (1972–88). His work is held in numerous private and public collections across Canada.

Jack Goldstein
27 September 1945, Montreal, Que. – 14 March 2003, San Bernardino, Calif. Having moved to Los Angeles at a young age, Jack Goldstein earned a Bachelor of Fine Arts at Chouinard Art Institute, South Pasadena, Calif. (1969) and a Master of Fine Arts at the California Art Institute, Valencia (1972). He held solo exhibitions at several venues, including the California Art

Institute, which involved a performance (1972); Metro Pictures and the Kitchen, New York (1980); Power Plant, Toronto (1991); and Whitney Museum of Modern Art, New York (2002). Goldstein's *Under Water Sea Fantasy* showed posthumously at the 2004 Whitney Biennial, New York.

Martin Honert

Born 26 May 1953, Bottrop, Germany. Martin Honert attended the Staatliche Kunstakademie Düsseldorf (1981–88), completing a Masterclass with Fritz Schweizer (1985). His exhibitions include solo shows at Galerie Johnen + Schöttle, Cologne (1988); Galerie Rüdiger Schöttle, Munich (1988); and Matthew Marks Gallery, New York (2004). In 1992 he was featured in the Biennale of Sydney and participated in the group exhibition *Who, What, Where? A Look at Art in Germany in 1992*, Musée d'Art Moderne de la Ville de Paris, and Museum für Moderne Kunst, Frankfurt. He showed at the 1995 Venice Biennale along with fellow German artists Katerina Fritsch and Thomas Ruff. Honert lives and works in Düsseldorf and Dresden.

Osuitok Ipeelee

Born 23 October 1922, Necouleetalik Camp, N.W.T. Osuitok Ipeelee began carving ivory in the 1940s, selling his work to Roman Catholic missionaries. His work has been featured in many group shows, including *Eskimo Art*, National Gallery of Canada, Ottawa (1952); *The Eskimo*, Museum of Fine Arts, Houston (1969); *Cape Dorset – Selected Sculpture from the Collection of the Winnipeg Art Gallery*, Winnipeg Art Gallery (1975); and *Imaginario Inuit: Arte e cultura degli esquimesi canadesi*, Galleria d'Arte Moderna e Contemporanea, Verona, Italy (1995). He has also held a number of solo exhibitions, and in 1993 received a medal from the Royal Canadian Academy of Arts. Ipeelee has lived and worked in Cape Dorset since the mid-1950s.

Liz Magor

Born 11 April 1948, Winnipeg. Liz Magor studied at the Vancouver School of Art in 1971, after spending two years at the Parsons School of Design, New York. She has exhibited nationally and internationally, with solo shows at the Art Gallery of Ontario, Toronto (1986); Vancouver Art Gallery (2002); and Power Plant, Toronto (2003). Recent group exhibitions include *Notion of Conflict: A Selection of Contemporary Canadian Art*, Stedelijk Museum, Amsterdam (1995); *InSITE*, San Diego and Tijuana (1997); and *From Baja to Vancouver*, Wattis Institute, San Francisco, Vancouver Art Gallery, and Museum of Contemporary Art, San Diego (2004). In 2001, she was nominated for the Millennium Prize, National Gallery of Canada, Ottawa, and received a Governor General's Award for the Visual Arts. Magor lives and works in Vancouver and teaches at the Emily Carr Institute of Art and Design.

Mario Merz

1 January 1925, Milan – 9 November 2003, Milan. A self-taught painter and sculptor, Mario Merz held his first solo exhibition at Galleria la Bussola, Turin, in 1954, with later shows at Sonnabend Gallery, New York (1970); Israel Museum, Jerusalem (1983); and Musée d'art contemporain de Montréal (1987). He participated internationally in many group shows, including Germano Celant's 1969 exhibition *Arte Povera*, Galleria La Bertesca, Genoa; the 1970 Tokyo Biennial; *Documenta 5*, Musee Fridericianum, Kassel, Germany (1972); the 1997 Venice Biennale; and *Zero to Infinity: Arte Povera 1962–1972*, organized and circulated by the Walker Art Center, Minneapolis, and Tate Modern, London (2001–03). Retrospectives of Merz's work were shown at the Guggenheim Museum, New York (1989) and Castello di Rivoli, Turin (2005).

Giuseppe Penone

Born 3 April 1947, Garessio, Italy. Before graduating with a diploma in sculpture from the Academia di Belle Arte, Turin (1970), Giuseppe Penone had already made numerous outdoor sculptures involving trees and rivers in a forest near his native Garessio. In 1969 he held his first solo exhibition at Galleria Gian Enzo Sperone, Turin. In 1983 the National Gallery of Canada, Ottawa, introduced his work to the Canadian public through the exhibition *Giuseppe Penone*, and in 2004 the Centre Georges Pompidou, Paris, presented a major retrospective of his work. In 2001 Penone received the Schock Prize for the Visual Arts from the Royal Swedish Academy of Science, which is given to artists whose work involves "reconciling nature and civilization."

Bernadette Ivalooarjuk Saumik

Born 22 September 1938, Arctic Bay, N.W.T. Bernadette Ivalooarjuk Saumik's sculptures have shown in a number of group exhibitions, including *The Bessie Bulman Collection*, Winnipeg Art Gallery (1973); *Canadian Eskimo Art: A Representative Exhibition from the Collection of Professor and Mrs. Philip Gray*, Fine Arts Gallery, Montana State University, Bozeman (1979); *Festival of Birds*, Artic Circle, Los Angeles (1981); and *Multiple Realities: Inuit Images and Shamanic Transformations*, Winnipeg Art Gallery (1993). Her work is held in many private and public collections across Canada, among them the McMichael Canadian Art Collection, Kleinburg, Ont., Canadian Museum of Civilization, Gatineau, Que., and National Gallery of Canada, Ottawa. Saumik lives and works in Rankin Inlet, Nun.

Michael Snow

Born 10 December 1929, Toronto. Michael Snow is widely recognized as one of Canada's most influential living artists. He studied at the Ontario College of Art, Toronto, and worked as a commercial artist before completing his first film in 1955. His first solo exhibition was held at the Isaacs Gallery, Toronto, in 1957. Recent major retrospectives of his work include *Instant Snow: Rétrospective Michael Snow*, Centre Georges Pompidou, Paris (2002); *Into the Light*, Whitney Museum of American Art, New York (2001); and *Michael Snow: Almost Cover to Cover*, Arnolfini Gallery, Bristol, England (2001). He has received the Order of Canada (1982), a Guggenheim Fellowship (1972), and honorary degrees from the University of Victoria; Nova Scotia College of Art and Design, Halifax; and Brock University, St. Catharines, Ont. Snow has also taught at several universities, among them Yale University, New Haven; Princeton University, New Jersey; and École nationale de la Photographie, Arles, France.

Marc Tungilik

1913, Netjilik Ilani, N.W.T. (?) – 22 September 1986, Repulse Bay, Nun. Marc Tungilik began sculpting as a teenager, combining animal and human forms with Christian and shamanistic iconography. In 1948 his miniature walrus tooth carving of a bust of Christ was presented to Pope Pius XII. He held his first solo exhibition in 1973 at the Canadian Guild of Crafts, Montreal. Tungilik's work has been featured in many group shows, including *Eskimo Art*, National Gallery of Canada, Ottawa (1952), and *Shadow of the Sun: Contemporary Indian and Inuit Art in Canada*, Canadian Museum of Civilization, Gatineau, Que. (1988–89).

Irene F. Whittome

Born 4 March 1942, Vancouver. After attending the Vancouver School of Art, Irene Whittome studied in Paris under the engraver W. Stanley Hayter. She has participated in many group exhibitions; recent solo shows include *Consonance*, Centre international d'art contemporain de Montréal (1995), and *Bio-Fictions*, Musée du Québec, Quebec (2000), and Centre de l'image et de l'impression, La Louvière, Belgium (2002). She has been awarded the Gershon Iskowitz Prize (1997), Paul-Émile Borduas Prize (1997), Governor General's Award for the Visual Arts (2002), and an Honorary Doctorate from the Emily Carr Institute of Art and Design, Vancouver (2002). In 2005 she was appointed Officer to the Order of Canada. Whittome is Full Professor of Studio Arts at Concordia University, where she created the noted Open Media program.

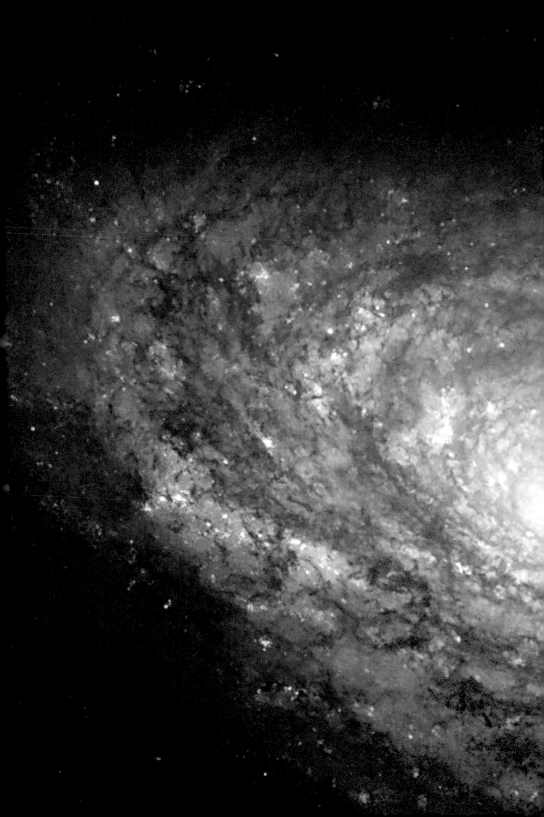

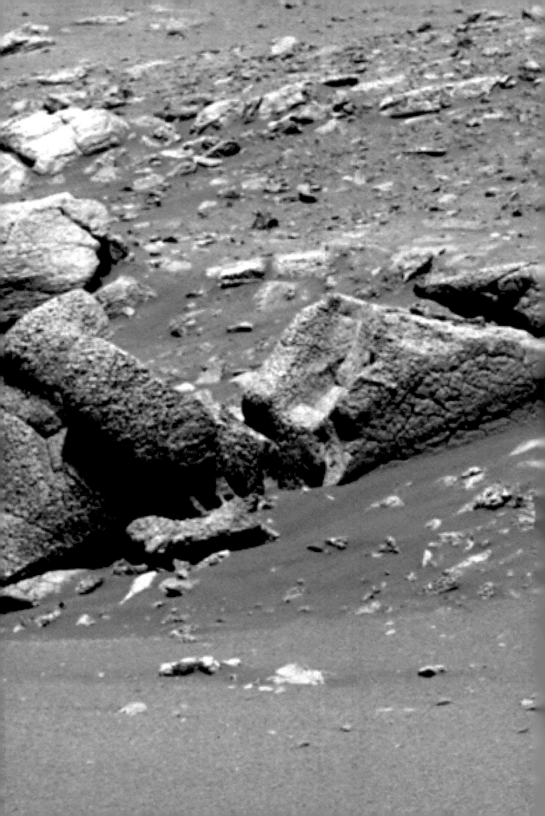

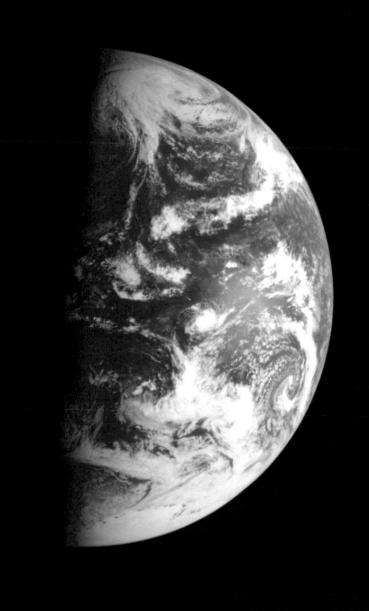

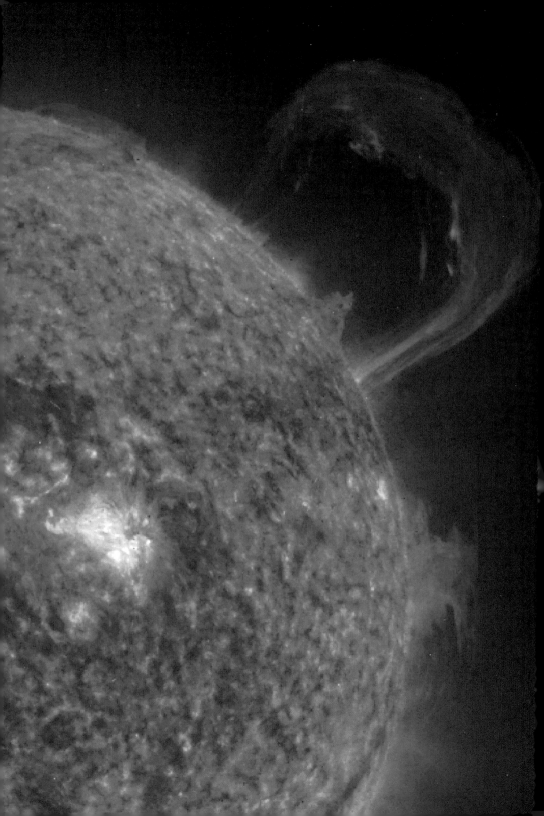